Manga Madness

David Okum

IMPACT
CINCINNATI, OHIO
www.artistsnetwork.com

About the Author

David Okum has worked as a freelance artist and illustrator since 1984 and has had his manga work published since 1992, beginning with a story in a *Ninja High School* anthology published by Antarctic Press. He has since been included in two other Antarctic Press anthologies and several small-press comic books. His writing and artwork have appeared in six books by Guardians of Order, publishers of *Big Eyes, Small Mouth* (the anime and manga role-playing game).

David studied fine art and history at the University of Waterloo and works as a high school art teacher.

Dedication

To my wife, Jen, and my daughters, Stephanie and Caitlin, for their patience and support to make this project a reality.

Acknowledgments

I'd like to thank the following people for their help and contributions:

Mark Mackinnon and Jeff Mackintosh from Guardians of Order for their support and advice.

Ben Dunn from Antarctic Press for publishing my first manga work.

The artists in the Anime North Artist Alley and the Online Comic Artist Community for showing me how it's done.

The staff and students of Eastwood Collegiate Institute, whose assistance and advice have made me a better teacher.

Stefanie Laufersweiler, Pam Wissman, Layne Vanover, Wendy Dunning, Karla Baker and Mark Griffin for sorting through my ramblings and making my work look good.

Doug Dublosque for finding my stuff in the first place and thinking it would make a swell book.

08 07 06 05 04 6 5 4 3

Library of Congress Cataloging in Publication Data

Okum, David.
 Manga madness / David Okum.— 1st ed.
 p. cm
 Includes index.
 ISBN 1-58180-534-9 (pbk. : alk. paper)
 1. Comic books, strips, etc. —Japan—Technique. 2. Cartooning—Technique. 3. Comic strip characters. I. Title.

NC1764.5.J3O48 2004
741.5—dc22 2003061951

Editor: Stefanie Laufersweiler
Production editor: Layne Vanover
Designer: Wendy Dunning
Production artist: Karla Baker
Production coordinator: Mark Griffin

Metric Conversion Chart

To convert	to	multiply by
Inches	Centimeters	2.54
Centimeters	Inches	0.4
Feet	Centimeters	30.5
Centimeters	Feet	0.03
Yards	Meters	0.9
Meters	Yards	1.1
Sq. Inches	Sq. Centimeters	6.45
Sq. Centimeters	Sq. Inches	0.16
Sq. Feet	Sq. Meters	0.09
Sq. Meters	Sq. Feet	10.8
Sq. Yards	Sq. Meters	0.8
Sq. Meters	Sq. Yards	1.2
Pounds	Kilograms	0.45
Kilograms	Pounds	2.2
Ounces	Grams	28.3
Grams	Ounces	0.035

table of Contents

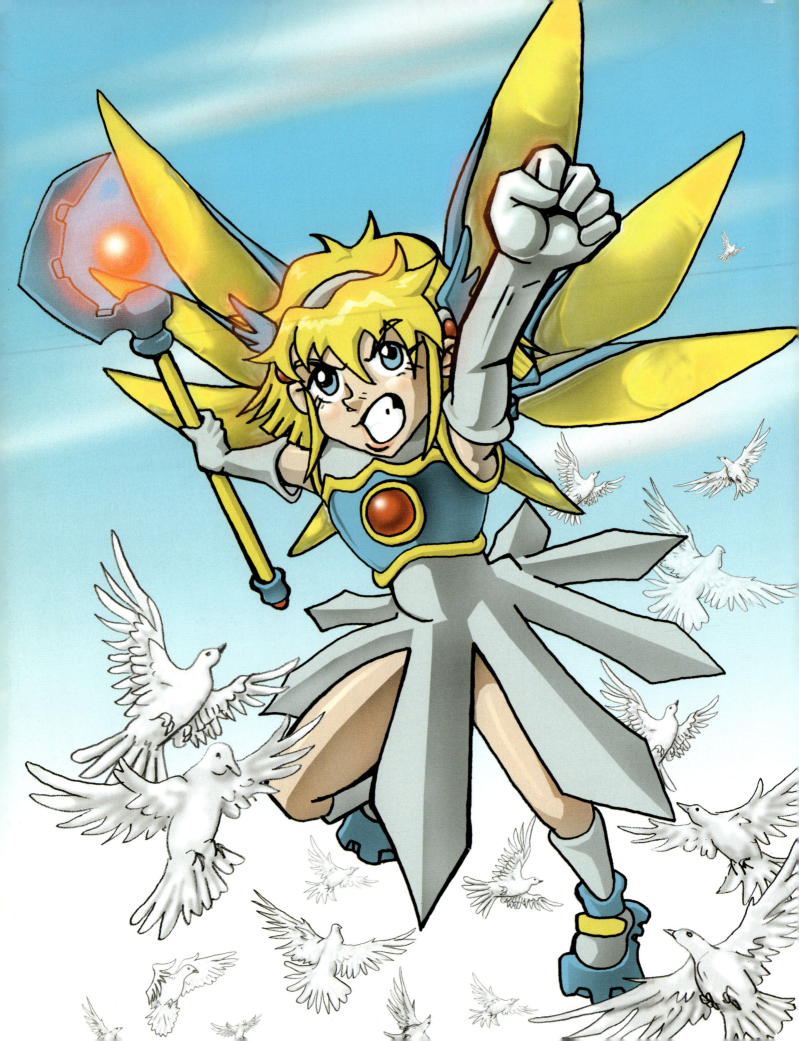

Introduction

This book is designed to help artists who are just getting started learning the basics of creating their own manga. We'll start with getting a grasp on the style, history and basic categories of Japanese comics. We may be attracted to the dynamic images, but manga also tells stories in a unique way with specific cultural and stylistic references. The more you know about manga, the better your work will be.

From there we will move on to some basic drawing guidelines and techniques. Built on this foundation is the heart of the book: lessons that help you draw manga characters step by step. These examples cover a wide variety of categories and character types and are provided as hands-on instruction for eventually developing your own characters. It won't be long before you are creating a whole cast for your own original manga.

Drawing characters just standing around gets boring after a while, so the next section of the book focuses on drawing action, settings and vehicles. Putting all the elements together is the key to storytelling and uses many skills. The best manga artists must be writers, artists, architects, actors, directors and cinematographers, and have a keen sense of design and layout. Who knew all that work could be so much fun?

I've been drawing manga-style art since I've been drawing. I love the exaggeration and expression in the style. My first opportunity at getting my manga art published came in 1992 from Antarctic Press, which has been publishing the excellent *Ninja High School* comic since 1987. It was so much fun that I published in two more Antarctic Press comics and then started publishing my own work. I moved on from manga to book illustration and writing for role-playing games, but I also create traditional acrylic paintings and paper sculpture.

No matter what your motivation for drawing manga, just remember to enjoy yourself, keep drawing and never, ever give up. Your skills grow every day, and the more you work to develop them the stronger they will become. Don't limit your art to just comics, either. Try sculpture, painting, computer art and crafts. The skills you learn in these other forms of art will make your manga art even stronger.

Let's get started making manga!

Before you begin

You don't need a fully equipped art studio to make manga. Here are some basic tools of the trade you *will* need.

A clean, flat, well-lit drawing surface. A drawing table, desk, kitchen table or even a coffee table will do.

Paper or board to draw on. Professional comic and manga artists use 2- or 4-ply bristol board sheets cut to 11" x 17" (28cm x 43cm). Most of the images in this book were drawn on 8½" x 11" (22cm x 28cm) sheets of bond printer paper. You can find reams of 500 sheets at any office supply store.

Try different types of paper and use what you are comfortable with. You might start out with only a half-used notebook or pieces of scrap paper. No matter what you draw on, keep a sketchbook and draw in it every day.

Pencils. Pencils come in a wide range of hard (H) and soft (B) varieties. Soft pencils (such as 2B or 4B) make nice dark marks, but are hard to erase and tend to smudge easily. Hard pencils (such as 2H or 4H) make fine light lines, but can scratch into the paper or board, leaving unwanted indentations that can make inking and coloring difficult. Some artists prefer HB pencils because they are the most flexible and readily available.

Technical pencils are favored by many artists because of the precise and consistent lines they make. Almost all the line art in this book was done with a technical pencil.

A good pencil sharpener. Keep your pencils sharp. Sharp pencils allow the artist total control over what he or she draws. An electric pencil sharpener speeds up the process, but don't forget to replace the blade when it gets too dull. Hand-held sharpeners work well too; just watch out for those pencil shavings.

Erasers. Erasers are very important to clean up any unwanted lines. White plastic erasers are preferred over pink erasers because they don't grind into the paper or smudge. Clean your plastic erasers occasionally by erasing on a piece of scrap paper until they look white again.

Inking pens. Keep on hand a variety of thick and thin markers. Be careful with inking. The wrong marker can ruin your hard work. Test your inking pens on scrap paper first. Some markers can really bleed into the paper or board. If possible, try to use India ink or permanent pigment technical pens. The ink shouldn't fade or turn brown like some felt-tip pens.

Traditional nib and holder pens that are dipped into India ink are used by most professional manga inkers. The variety and control of line that is available with these pens in the hands of an expert is amazing. Purists insist on using these pens, claiming that the lines are much more expressive and polished.

The ultimate test of inking control is inking with a fine brush. The warm, calligraphic touch of the brush adds a level of craftsmanship and humanity to the artwork that technical pens cannot duplicate.

Screen tone. Traditional manga uses dry transfer tone patterns for shading. Screen tone can be found at larger art supply stores and comic book conventions, or online. The painstaking process of applying screen tone

requires the artist to carefully cut out the chosen area of tone with a sharp blade and then place the transfer neatly on top of the inked artwork. Some artists use computers to simulate screen tone effects. Screen tone is not essential to create your own manga, but it is often used by professionals because the tiny dots are easy to reproduce in printing.

Colored pencils. Soft colored pencils allow for a wide range of shading and blending. They are relatively inexpensive, easy to use and come in a variety of colors. Try blending and shading using little circles and moving the pencil along the natural shapes and forms of the object you are drawing.

Colored markers and paints (optional). Colored markers and paints add a whole new dimension to manga work, but can be difficult to master. Markers are expensive and may give off hazardous fumes. Water-

based markers are washable and nontoxic, but smudge easily and don't blend well. Various coloring methods such as markers, paint and computers are discussed on pages 19-21.

A ruler or straightedge. Rulers are most important for drawing perspective lines properly and creating comic panels in manga.

Flat storage for your drawings. Don't let your drawings get folded or crumpled, ruined by a water mark (oops!) or accidentally tossed in the trash. Keep them flat and protected by storing them in a simple, labeled folder or art portfolio.

how did Manga begin?

The comic book is a relatively recent invention, but Japanese artists have been producing illustrated books for centuries. The famous Japanese artist Hokusai (1760–1849) coined the term *manga* in 1815 when he referred to some of his comic sketches as "man" (whimsical or careless) "ga" (drawings).

Japanese manga developed a strong following after World War II. The themes and stories reflect popular culture and national tastes. People unfamiliar with manga are sometimes surprised by how violent and racy some Japanese comics can be. There is a wide audience of women, men, boys and girls that accepts comics and animation as just another medium for storytelling. Manga is produced for every possible group and interest.

Manga produced in Japan is published weekly as part of huge 300+ page anthologies of comic stories. They are regarded as cheap entertainment for commuters, read and then discarded. They usually aren't preserved as precious artifacts like American comic books. They are consumed, not collected. High demand creates crazy schedules for manga artists, who often pump out sixteen or more pages a week.

The Japanese fan base is truly amazing, with tens of thousands of people attending conventions in an attempt to catch a glimpse of their favorite artists. Fans also create elaborate costumes and dress up as popular manga characters. Artistic fans can try their hands at

doujinshi, amateur comics about their favorite manga and anime characters.

The demand for manga has increased as the rest of the world discovers the medium. Translation of manga is difficult because most Asian books are read from right to left, opposite from most European and North American books.

Purists generally do not call non-Japanese comics "manga," even if they are drawn in the appropriate style. Non-Japanese manga is called "American manga" or "Western manga." The North American comics market has different economics and expectations. American manga are often produced in glossy color and include traditional Western storytelling and cultural elements such as superheroes.

The future of manga looks bright. Many mainstream comic companies are adopting a manga "look" for their books. Even comics like *X-Men* and *Batman* have been drawn in manga style by Japanese manga artists. Anime has become wildly popular on television and in the movies. Manga books as well as anime shows, movies and video games are winning more mainstream awards and becoming accessible to a whole new legion of followers.

Common Manga Terms to Know

Anime (AH-nee-may)—French term for "animation" adopted by the Japanese to describe all of Japanese animation.

Bishoujo (bee-SHO-jo)—"beautiful girl."

Bishounen (bee-SHO-nen)—"beautiful boy."

Chibi (CHEE-bee)—"small"; refers to a child-proportioned version of a manga character, often used for comic relief. Also referred to as SD (super-deformed).

Doujinshi (doh-JEEN-shee)—fan-produced manga involving favorite manga, game and anime characters in original stories.

Kawaii (kah-WAH-ee)—"super cute."

Manga (MAHN-gah)—"whimsical or careless drawings," meaning Japanese comic books.

Otaku (oh-TAH-ku)—nickname given to someone obsessed with being a fan, often referring to anime and manga fans.

RPG—a video role-playing game, often with complex settings and characters. Many manga and anime artists help design popular video games.

Shoujo (SHO-jo)—"young girl"; refers to comics aimed at young girls.

Shounen (SHO-nen)—"young male"; refers to comics aimed at young males.

how the
Pros do it

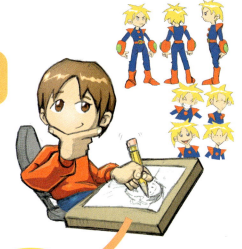

Ever wonder how your favorite comic book was put together? Usually a whole team of different people—writers, editors, pencillers, letterers, inkers, colorists and a publisher—is required to produce just one story.

1 Brainstorming
Come up with a really cool idea or character. Write down lots of ideas and draw up a model sheet (at least three or four views of the character) and an expressions reference sheet to keep everything consistent as you draw.

2 Writing the Script and Drawing a Rough Layout
A script provides a written breakdown of the story, and a layout shows the page and panel breakdown. The layout is often drawn just with rough stick figures. Care is taken to balance the dialogue so that it doesn't overwhelm the artwork. The script and layout might be completed by two or more different people.

3 Pencilling
After the story and layout have been finalized, the final pages are begun. Heavier paper is often chosen so that the pages will survive the lettering, inking, erasing and coloring to come. Lines are drawn sparingly and lightly, and instead of filling in areas of black, X's are placed for the inker to fill in later.

4 Lettering
Most of the lettering in professional comics is done last on the computer, over the existing artwork. Any lettering done by hand is completed at this stage. Each word is carefully printed out in uppercase.

5 Inking
All images are inked so that they are permanent. Great care is taken at this stage, since you can't erase ink. Minor errors can be covered with white paint or correction fluid.

6 Erasing
Once the ink is completely dry, all original pencil lines are removed for a clean look.

7 Coloring
Most manga are colored with a computer, but there is still a huge market for well-done hand coloring.

8 Publishing
Not every comic is a full-color glossy. Many beginning artists publish small, photocopied, folded and stapled mini-comics. The rise of the Internet has seen an explosion of online comics and manga.

of *manga style*

Individual manga can vary wildly in style and technique. Each manga is as unique as the individual who created it. There is no stereotypical manga style, but there are some standard conventions that have developed over the years.

Hair is wild and flowing, reflecting popular styles and revealing the nature of the character.

Noses are often less prominent and simply drawn as a small checkmark.

Mouths are small when closed and very large when open. Avoid details like lips—keep it simple!

Eyes are large and exaggerated, sometimes taking up more than a third of the character's face.

The Eyes Have It

The first thing people notice about manga characters is the size of the eyes. Huge eyes make the characters appear young and innocent, and provide a dynamic means of expression. Another reason for characters with large eyes has its origin in Japanese theatrical makeup. To depict ideal beauty, actors often shave their eyebrows and paint them higher on the forehead. The eyes then look huge from the audience's perspective.

manga categories:
Shounen and *Shoujo*

Shounen (boys' manga)

Shounen can trace its origins to the work of Tezuka Osamu, creator of *Astro Boy*. *Astro Boy* was a robot boy comic created by Osamu in 1951, and in 1963 was one of the first manga characters animated in his own cartoon. *Astro Boy* was translated into English and broadcast on American television in the 1960s. Osamu revolutionized the art and craft of manga in the late 1940s when he started using cinematic techniques such as dynamic angles and closeups. His stories were exciting and intense, and more importantly, they did not always have happy endings.

Many shounen manga comics are about Japanese history, combat, action, science fiction, giant robots, and sports such as soccer and tennis. The standard theme is conflict. A single hero and his friends must somehow overcome overwhelming threats. In the course of the story, the heroes usually learn something about friendship, loyalty and the power of spirit. The villains are vile and the heroes always seem close to despair and defeat, but friendship and inner strength usually win the day. There is often a lot of posturing and showing off of fancy martial arts moves or high-tech weaponry.

Shoujo (girls' manga)

Shoujo manga developed in Japan during the 1950s and 60s. Many female artists and writers created stories of character, relationships and depth aimed at middle-school girls. As manga readers aged, manga matured with them, focusing on age-appropriate stories of high school or soap-opera stories of adults in complex relationships.

Shoujo manga tends to focus on slice-of-life stories, and the fantasy or science-fiction elements all but disappear in manga aimed at older readers. At its heart, shoujo manga is about relationships, friendship, romance and family. Shoujo manga also has a history of wacky humor and over-the-top cuteness at almost toxic levels.

meet the Good Guys

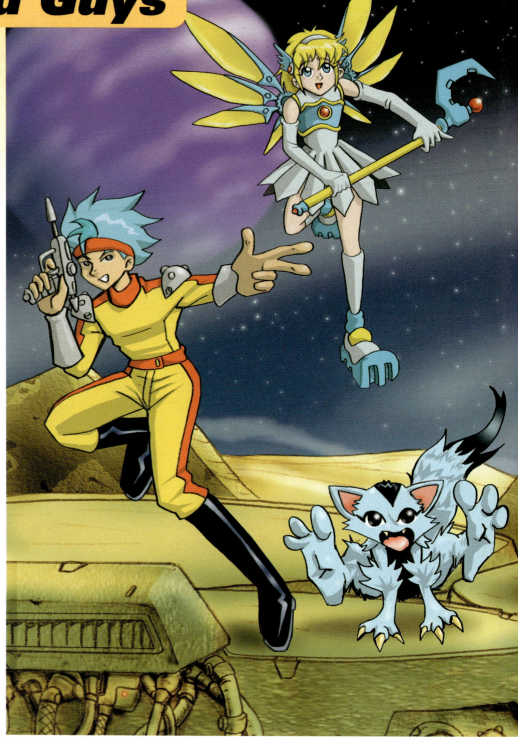

Here are some of the most common heroic characters that appear again and again in manga. Manga heroes are often young characters who are connected to the villains in some way. For example, they may be related to or romantically linked with their enemies. This adds a great amount of complexity to the story; the main conflict actually occurs *within* the hero as opposed to simply between the hero and an outside force.

Manga heroes are frequently depicted as exciting adventurers with a very exaggerated sense of cool, but usually they are the butt of some prank or embarrassment. This allows the reader to relate to them as they "feel" their humanity. Comic relief does not seem to take away from the intensity of the dramas depicted in manga.

Each "good guy" brings a unique set of skills and abilities to the group.

The Dashing Hero is the focus of the story, often going against authority when necessary in order to save the day.

The Magical Girl often has royal connections or is a princess who proves herself to be quite capable, even rescuing the Dashing Hero from time to time.

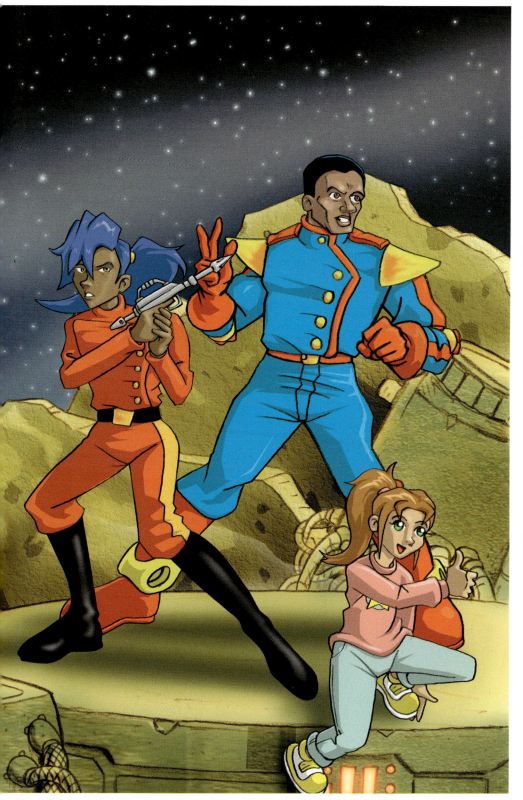

The Rebellious Hero usually is much more powerful than the Dashing Hero, but his pride or rebellious nature stops him from rising to the heights of the true hero.

The Big Guy is a giant with a soft heart who seems to be simply mindless muscle, but often is the technical wizard of the group.

The Kid not only relates young readers to the story, but provides a character who is typically in need of rescuing or training. Many of the problems the heroes face result from something the Kid has done or that has happened to him.

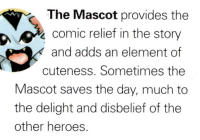

The Mascot provides the comic relief in the story and adds an element of cuteness. Sometimes the Mascot saves the day, much to the delight and disbelief of the other heroes.

here come
the Bad Guys

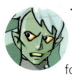The bad guys are often more popular with fans than the heroes. Manga villains are rarely the snarling evildoers common in Western comics. They have hopes and dreams and family histories. Great effort is usually given to make them sympathetic characters, enhancing the tragedy of their conflict with the heroes and their ultimate defeat.

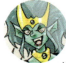**The Big Bad** is usually the leader of the villains. He can appear as a raging fool for comic relief, but he is usually much more than that. The best Big Bads are much more powerful than the heroes, using their brains to develop plans that just might work. The Big Bad is an honorable opponent who secretly respects the bravery of heroes who stand up against seemingly overwhelming odds.

The Evil Queen is sometimes cast as the Big Bad, but more often is the one who gives the Big Bad his orders. She usually has powerful technology or magic and seeks something belonging to the heroes or something that they have taken from her.

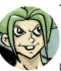**The Fallen Hero** is often presented as a warning to heroes of what could happen to them if they make the wrong choices in life. The Fallen Hero has taken the easy way out and joined the dark side, tempting the heroes with power and riches if they would just do as he did.

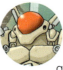**Mindless Goons** are generally just there to get in the way or to present a generic threat to the heroes. Every now and again, however, it is fun to mix things up and present some Goons as individual characters who are a challenge for the heroes to defeat.

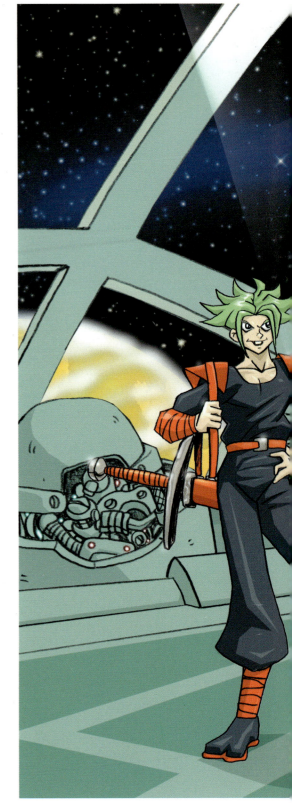

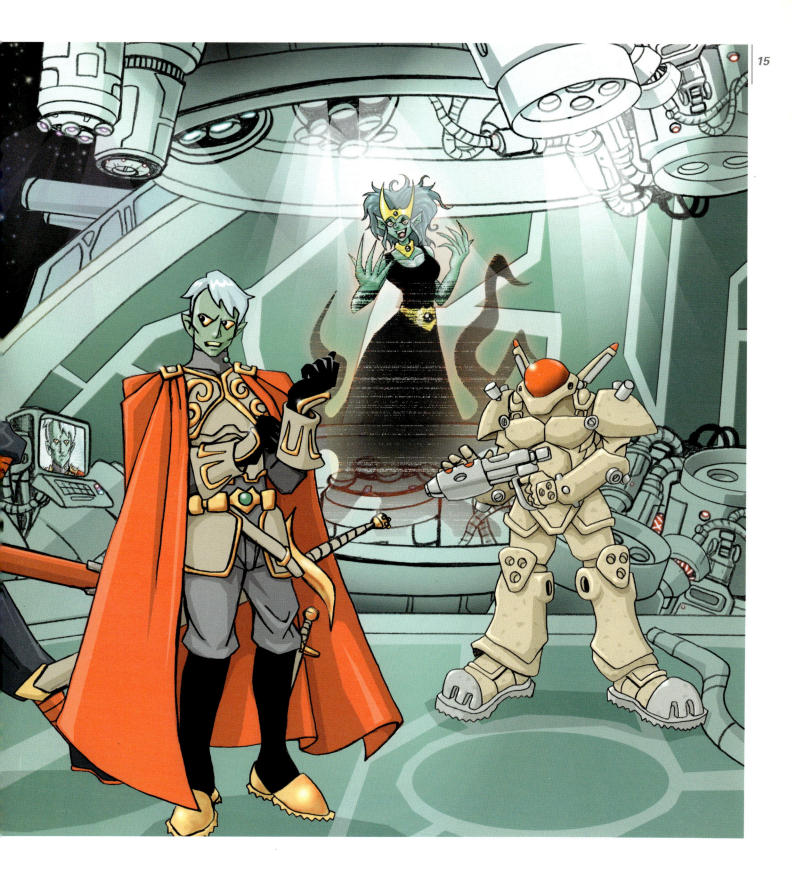

complex shapes
start with Basic Ones

If you look at anything closely enough, you will begin to see that objects are made up of four basic shapes: circles, squares, rectangles and triangles. Actually, because objects are three-dimensional, not flat, you are really seeing a bunch of spheres, cubes, cylinders and cones.

Combine these basic 3-D forms in different ways and you suddenly can create an infinite number of new objects.

Drawing complex forms like the human figure or spaceships can be very intimidating, but most beginners can handle drawing things like spheres, cones, cylinders and cubes. Grab your pencil and try out some of these forms. Don't be overly careful; have fun and stay loose. It should take only a few minutes to fill a page with 3-D forms.

The human figure is really just a collection of cylinders and spheres.

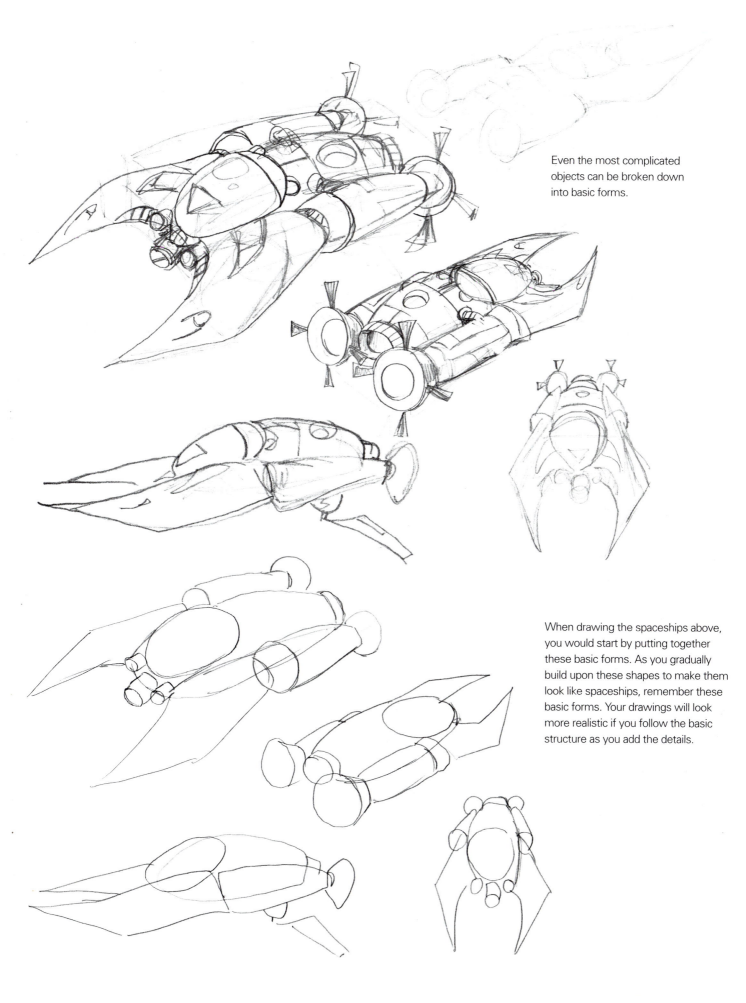

Even the most complicated objects can be broken down into basic forms.

When drawing the spaceships above, you would start by putting together these basic forms. As you gradually build upon these shapes to make them look like spaceships, remember these basic forms. Your drawings will look more realistic if you follow the basic structure as you add the details.

using shading for 3-D Effects

*T*o make forms look real, you need to consider the way light falls on them and how they cast shadows. When shading, apply four to six levels (or values) of gray, from lightest to darkest, on your subject. This makes your drawing much more believable and realistic.

Know where the light is coming from before you start shading your drawing. Highlights are the brightest areas of light falling on an object or character. They often appear dramatically on the surface, reflecting the light. It is best to leave them white and carefully draw around the highlights. Use an eraser to clean up any lines or smudges on your drawing.

To make your drawing look three-dimensional, follow the form of the object you're shading as you drag the pencil or paintbrush across the paper. Imagine you are wrapping the forms in string and each pencil or brushstroke is a strand. Your pencil lines should literally wrap around the form.

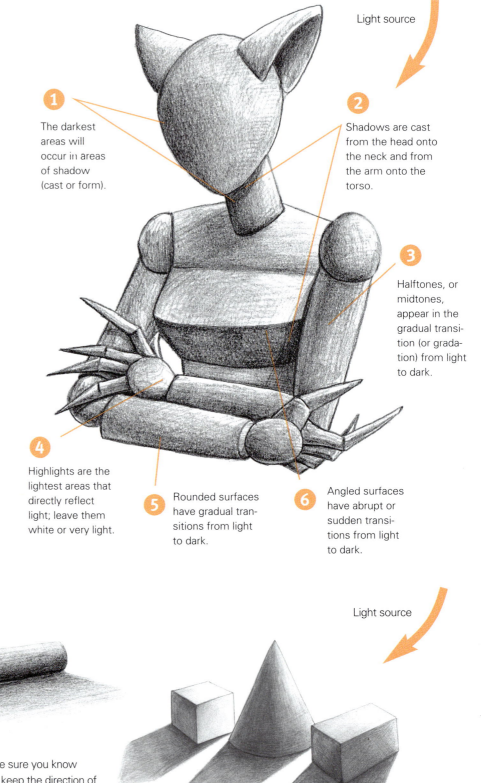

Light source

1 The darkest areas will occur in areas of shadow (cast or form).

2 Shadows are cast from the head onto the neck and from the arm onto the torso.

3 Halftones, or midtones, appear in the gradual transition (or gradation) from light to dark.

4 Highlights are the lightest areas that directly reflect light; leave them white or very light.

5 Rounded surfaces have gradual transitions from light to dark.

6 Angled surfaces have abrupt or sudden transitions from light to dark.

Light source

Light source

Try shading a few simple forms. Make sure you know where your light is coming from, and keep the direction of that light the same for all of the objects in your drawing. Notice how the change from light to dark is gradual on round objects and more abrupt on angular ones.

Soft Shading
VS. cel shading

*E*arly on you have to make a decision whether your artwork will be shaded realistically (soft shading) or stylistically as you see in anime (cel shading).

Cel shading is a reference to the animation process, where color is painted on a plastic transparent sheet (or cel) that is layered with a separate cel of the drawing to make a complete image. Cel shading uses bright and bold colors in a very stylized way. The areas of shadow are usually harshly depicted from the areas of midtone. Highlights are done in a similar sharp-edged manner.

Soft shading allows for a smoother transition from light to dark and therefore appears to be more realistic. Subtle details are easier to depict (such as the breath vapor and the texture and material of the coat). Overall the image is softer and less harsh. Soft shading is often used in Western comics and 3-D computer animation. Soft shading is also used for covers of manga and often for shoujo manga.

The differences between these types of shading are striking and can really change the look and feel of your drawing. Both techniques of adding color can be done by hand or with a computer. Just remember: Color can't fix a poor drawing, but a great drawing can be totally ruined by poor coloring.

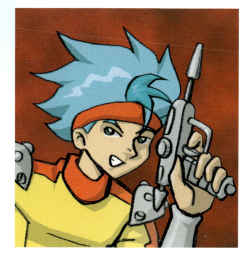

Cel Shading

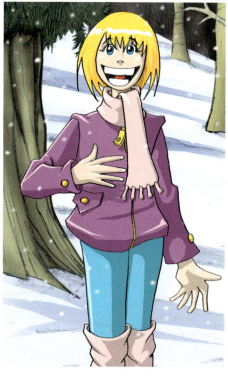

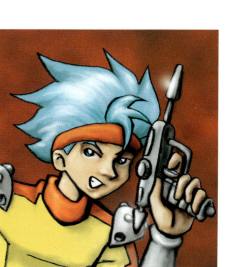

Soft Shading

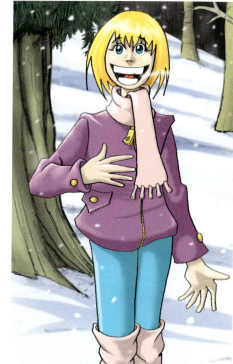

more than one way
to Add Color

You can color your drawings in a couple of different ways. No matter what coloring media you choose to use, try to create the illusion that your image is three-dimensional. You want your characters to look real, not flat and lifeless.

Colored Pencils

Because they are convenient and relatively cheap, this is a good medium for beginners. Both the texture and quality of the paper is a very important factor when drawing with colored pencil. Paper that is too bumpy can be difficult to control. Vary the pressure of the pencils to make the color soft or solid.

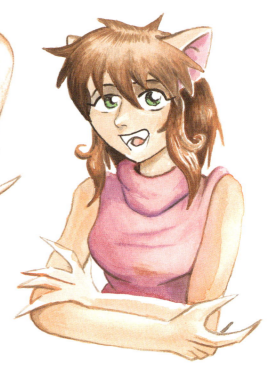

Markers

Markers are one of the toughest mediums to use properly because they bleed into paper in almost uncontrollable ways, and they are difficult to change once they are down. Artists enjoy their bright colors and the fact that they look very much like anime cels. Some marker errors can be touched up using a pencil crayon at the end. Shading with markers is usually done to appear as if it were cel shading, mainly because it is difficult to blend softly with markers.

Watercolors

Watercolors are traditionally used in shoujo manga. The results are softer and more personal than the outcome of marker or computer coloring. When painting with watercolors, start with light colors and end with darker colors. It is almost impossible to paint a light color on top of a dark color because the water makes the paint so transparent that you can see through the lighter layer to the darker layer underneath.

Colorless Manga

Most manga from Japan is printed totally in black and white. Printing costs and production time make full-color comics very rare in Japan. Color is usually reserved for covers and promotional art. Often, it isn't until manga is turned into anime that fans see the characters in full color.

Colored Pencil Tips

If you're like most beginners you'll probably start out with colored pencils. Some tips:

- Make your first graphite pencil marks light. Erased lines can show up as "ghost lines" when you draw over them with colored pencil.

- For even coloring instead of streaks, build up areas of color slowly using regularly spaced crisscrossing lines. Pressing too heavily will build up areas of wax that will be difficult to draw on top of.

- Know where the darkest and lightest areas of your drawing are before you start shading. Draw lightly first, then shade in the darker areas. Shade in small circles, applying pressure slowly.

- To darken an area of color, add the color's complement instead of black. For example, add green to red, blue to orange or purple to yellow. This will make your darks vibrant instead of harsh.

- Keep colored pencils sharp for more control.

- Use a white pencil crayon as a neutral medium to blend colors together and to flatten streaky areas.

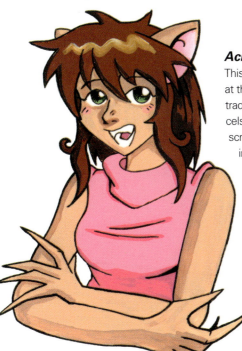

Acrylic on Acetate

This method really allows you a glimpse at the tremendous effort that goes into traditional animation, where multiple cels may result in only one second of screen time. Simply transfer a drawn image onto an acetate sheet using a photocopier, then apply thick acrylic paints on the back of the sheet to color the image. The shadowed areas are usually blocked in first and appear cel-shaded. If you try this method, use thick craft paint, which covers the plastic better than some acrylics and comes in a wider range of colors.

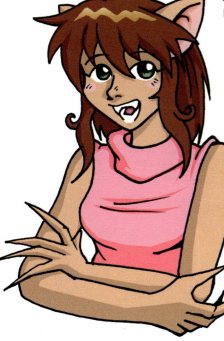

Computer Coloring

Most manga and comic book coloring is done on computers with programs such as Photoshop and Paint Shop Pro. Shading with the computer can be done smoothly (soft shading) or sharply (cel shading). The program that you use for coloring on the computer will make that decision for you. Coloring with computers requires a good deal of practice and technical ability. Many Internet artist groups provide excellent online tutorials to help you get the hang of it.

drawing Eyes

One of the most striking and recognizable features of manga is the way eyes are drawn. The eyes are large for expression and innocence. Villains and less innocent characters have narrow, more realistic eyes. Innocents have large, expressive eyes. In some manga, the eyes can take up to one-third of the face.

Take a look at how realistic eyes can be exaggerated and distorted to become manga eyes.

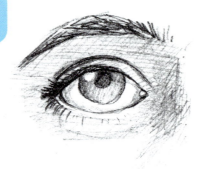

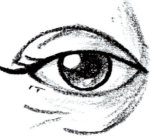

The first eye looks pretty realistic. By simplifying the basic shapes into lines, we can create a more stylized "cartoony" eye.

The eye can be stylized even further. Widening the eye will make the character appear young and innocent. The character's personality should dictate the size of the eye.

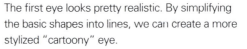

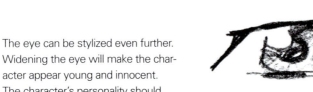

Manga eyes may be stylized in many ways. Don't add too much detail. It's better to draw the eyelashes as a solid mass or add one or two long lashes instead of every single eyelash. Eyebrows should also be drawn solid.

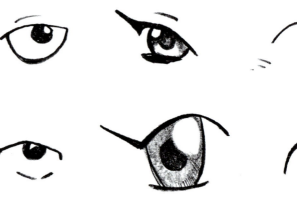

Closed eyes are often drawn as simple curves, usually with some eyelid and eyelash details. Draw tears playfully. When manga characters cry really hard, their eyes shoot large jets of water.

Eyes

1. Begin with a simple circle within a circle, or an oval within an oval. Make sure the pupil is in the center of the eyeball.

2. Cover at least one-third of the eyeball with the top eyelid. Keep the details of the eyelashes to a minimum.

3. Add the highlight on the eyeball. This will make the eye appear glassy and reflective. Make sure the light source is the same for all of your shading. Block in the areas of light and dark on the iris.

4. Finish the shading and clean up any extra lines with an eraser.

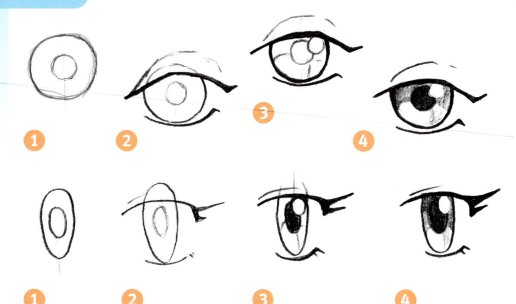

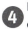 1 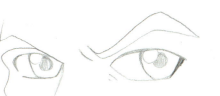 2 3 4

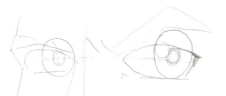 1 2 3 4

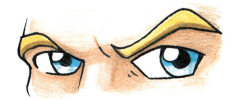

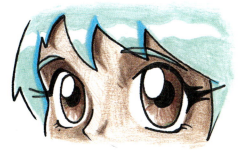

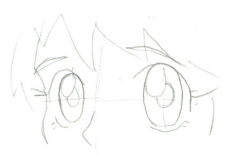

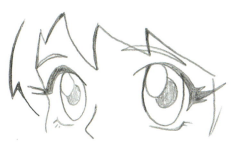

Now try drawing pairs of eyes. Keep each eye lined up on the eye line of the head. Realistic eyes generally have the space of one eye-width separating them. Less realistic ones may have a smaller space or even no space at all between them.

drawing Hair

There are no limitations to hair color or styles in manga. Manga hair has more to do with symbolism than fashion or physics. The more exotic or wild the character, the wilder the hair should be. Female manga characters have tendrils, or loose strands, in front of their ears. These strands may be thick or thin depending on the hair style.

If you are creating an original character, you may want to put some thought into the connections or manga references your choices might imply. The symbolism of the hair style and color may be interpreted differently, but there are some common suggestions.

What Hair Color Means

In manga, hair color can say as much about a character as hair style. Here are what some hair colors can mean:

Red = energetic, good fighter, outspoken, stubborn and strong-willed.

Blond = stands out in a crowd, youthful, naïve and a little ditzy.

White or silver = unnaturally powerful or magical and dignified.

Violet = exotic and knowledgeable, but somewhat secretive.

Green = unpredictable, good-natured outsider.

Metallic = futuristic and high-tech.

Brown or black = traditional or "normal." Easy to relate to.

Pink = naïve, innocent, bubbly and obnoxiously cute.

Blue = youthful, energetic, cool and introverted.

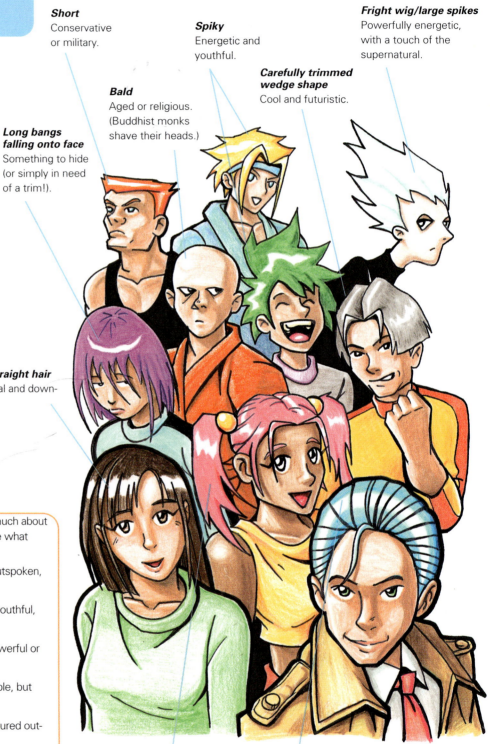

Short
Conservative or military.

Spiky
Energetic and youthful.

Fright wig/large spikes
Powerfully energetic, with a touch of the supernatural.

Carefully trimmed wedge shape
Cool and futuristic.

Bald
Aged or religious. (Buddhist monks shave their heads.)

Long bangs falling onto face
Something to hide (or simply in need of a trim!).

Long, straight hair
Traditional and down-to-earth.

Ponytails
Cute, energetic and a little ditzy.

Short and slick
Professional and conservative. May also indicate pride.

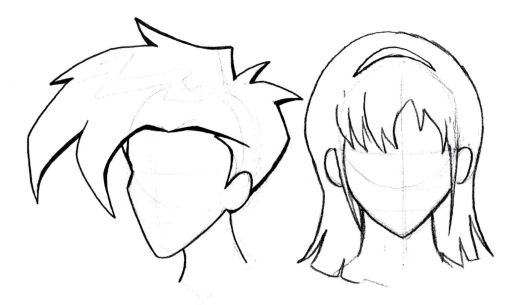

Manga hair should be drawn as a series of clumps or chunks. Long hair should appear softer and curve around the form of the skull.

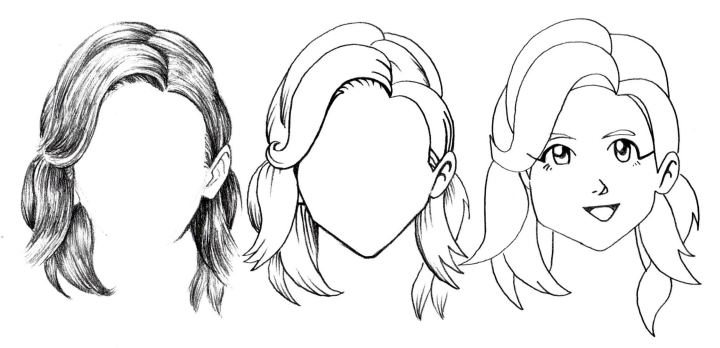

The hair on the far left is carefully created to appear realistic. The play of light and shadow on the hair is consistent and convincing. Break the hairstyle into chunks, simplifying it into uniform shapes for a manga look.

Don't Split Hairs

We all know hair is made up of countless strands. However, drawing each strand is not only impossible, but it doesn't look convincing. Instead, break the hair into chunks and indicate a few strands here and there with shading. Leave highlights white. Cel-shaded hair has a strong highlight across the top that can appear as a line or zigzag of white. The highlight must relate to the direction and angle of light falling on the head.

Face, *front view*

Manga characters come in all different shapes and sizes. Different artists have unique approaches to drawing faces. Some draw faces round and graceful, while others draw them long and lean. This lesson and those that follow provide a basic framework that should be modified depending on individual characters and your unique style. Use these guidelines to get a sense of proportion and anatomy and then use your imagination to create something original.

1 Lightly draw a circle, then draw a vertical guideline down the middle of it. Sketch the jaw—which can be long and pointed or rounded and soft depending on the character—placing the point of the chin in the center. Use your ruler to find the halfway point between the chin and the top of the head. Draw a horizontal guideline on a right angle with the vertical line. This will be the line on which you will draw the eyes.

2 Set the pupils of the eyes on the horizontal line, equally distant from the center line. Fill in the rest of the eye details, leaving almost enough room between the eyes for another eye. Leave some room on either side (about half an eye from the side of the head). Draw the eyebrows as solid shapes.

The base of the nose is located halfway between the eye line and the point of the

Start Light

Always draw lightly with pencil when you block out the main shapes of your drawings. The lighter lines erase more easily when you make mistakes. Prevent smudges by placing a scrap of clean paper on the artwork under your hand.

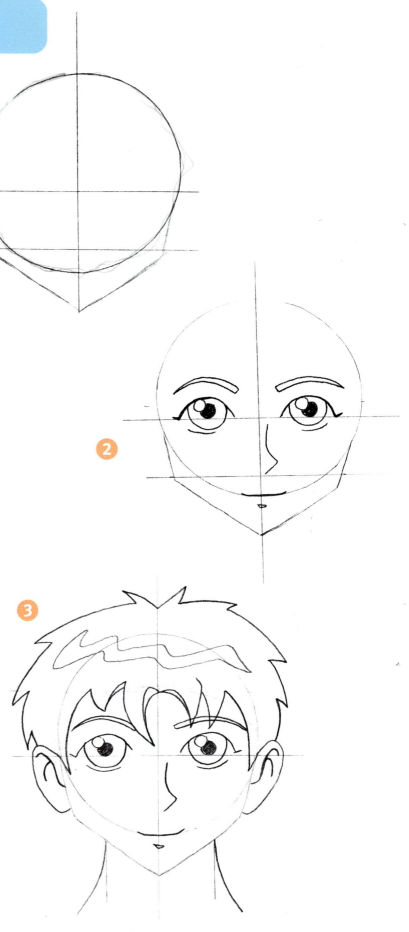

chin. Draw the nose as a simple checkmark pointing in the direction that the shadows will fall across the face. The mouth is drawn simply and is usually no wider than one eye when closed. When open, the mouth can take up over half the face.

3 Hair should rise off the head with some volume. If hair overlaps the eyebrow or eyes, it is traditional in manga to let the details underneath show through. This allows the artist to use the eyes for expression without changing the hairstyle.

Place the ears between the top of the eyes and the base of the nose. Draw the neck from the point where the ear rises off the skull. This point is usually as wide as the far corners of the eyes, but this can be exaggerated in manga. Usually only very powerful characters have thick necks.

4 Shade the final color image to appear 3-D. Carefully place highlights to show the points that rise off the head and catch the light. Areas of shadow are darkest in the eye sockets under the eyebrows and below the chin.

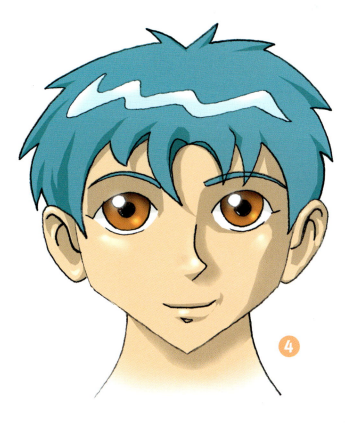

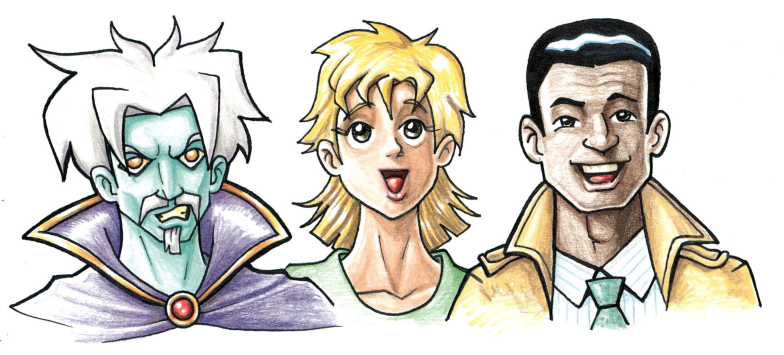

Face, *profile*

Now that you've mastered the front view, try your hand at the profile, or side view.

1 This gets a little tricky, so pay attention. Start by drawing a single circle, and draw the jaw with two sweeping curves. When you know how long the face will be, measure it (**a**). Use that distance to show where the back of the head should go. Draw a second circle the same size as the first, but move it over slightly to form the back of the skull.

Sketch the eye line halfway down the head, and then the nose line halfway down from the eye line to the chin. Place the ear at the back of the first circle.

2 Draw the eye with the pupil resting on the eye line. The eye shape is different from the way the eye appears from the front. The eye should be set almost one eye distance in from the front of the face. The nose should rise up from the nose line and extend from the face. Don't make the nose too large. The mouth is drawn off to one side, or sometimes not drawn at all. The jaw should slope up to the ear. The jaw of a male character is often drawn in a more dramatic and exaggerated way than a female character. The ear is seen from the side.

3 Clean up the underdrawing and define the final lines. Be careful not to make the nose too pointy or too squat. The nostril is hinted at with a single line. Have the hair

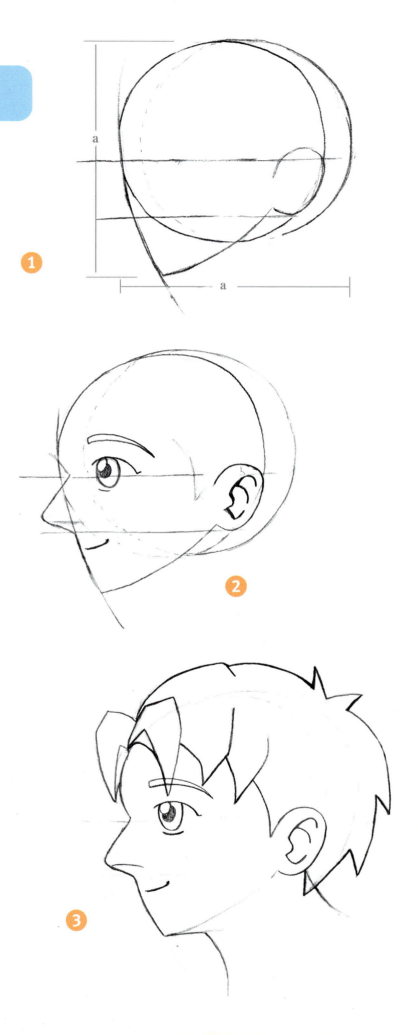

rise above the skull and spring onto the face as manageable chunks of hair.

The neck should drop down from the chin at the back corner of the eye. It should slope back and not drop straight down. The back of the neck begins at the base of the skull behind the ear, sloping back down at an angle.

4 The final color image helps define the shapes and planes of the face using light and shadow. Don't forget to shade the details of the ear and nose. Other details such as the lips may be hinted at as well.

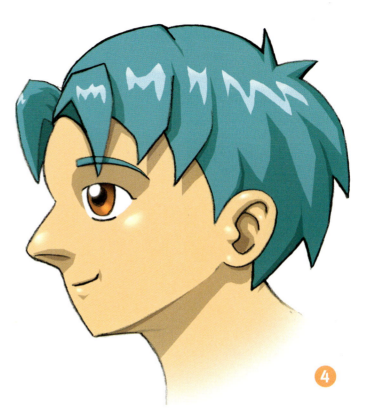

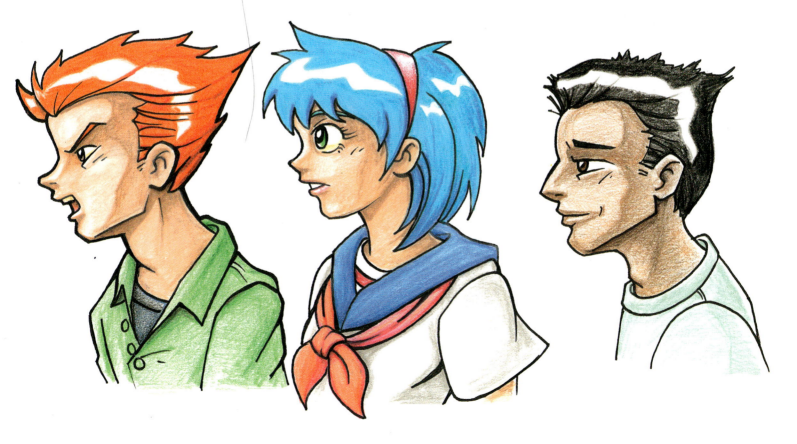

Face,
three-quarters view

This is one of the most common views of manga characters, but is also the most challenging. Try to think of the face as a three-dimensional object as you draw it. The curved surface will distort some details such as the eyes and nose, as you'll see here.

1 Draw a circle and extend the shape of the jaw down from the circle. Notice how the jaw is off to one side and uneven. The point of the chin is placed about a third of the way across the shape. Draw a curved vertical axis line to show the center of the face. Halfway down the axis is the eye line and halfway between that and the chin is the nose line.

2 Each eye has a distinct shape in this three-quarters view. The eye closest to you is similar to the basic manga eye shape, while the eye on the other side of the nose is shaped more like a teardrop. (Don't forget the highlights!) Indicate the indentation of the cheekbone and the brow ridge by drawing a small arrow pointing at the eyeball into the basic head shape. Block in the nose, mouth and ear with just a few simple lines.

3 The hair rises above the skull, and the nose should appear to rise from the face. Avoid drawing huge nostrils; indicate them with only a simple line. Characters who

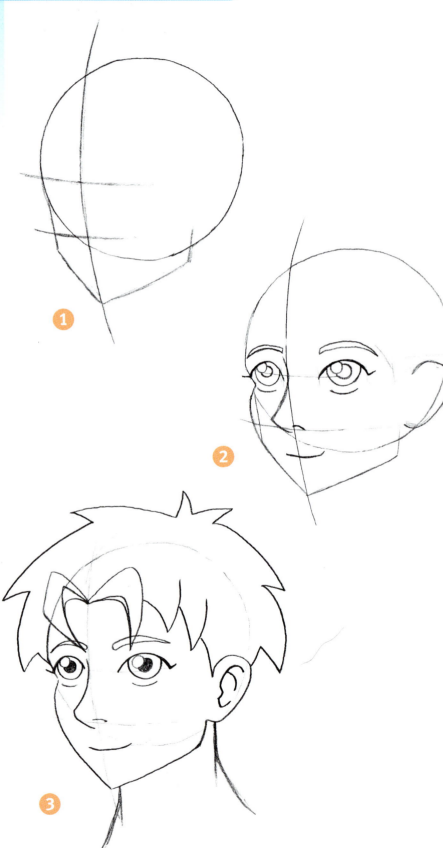

are bald or have very short hair may need smaller or narrower eyes to avoid distortion. Here, the eyebrows have been adjusted to appear square and more masculine.

The mouth should not have any lip details. Keep the mouth small when closed and really big when open. The neck drops down from the middle of the chin to the area below the ear lobe. Curve the edges out as it drops down.

4 The degree of realism you choose for coloring the drawing should be consistent throughout the image. Use shadows to define facial details such as the cheekbones and nose. Highlights add to the realism and provide further structural details such as the bridge of the nose and the purse of the lips.

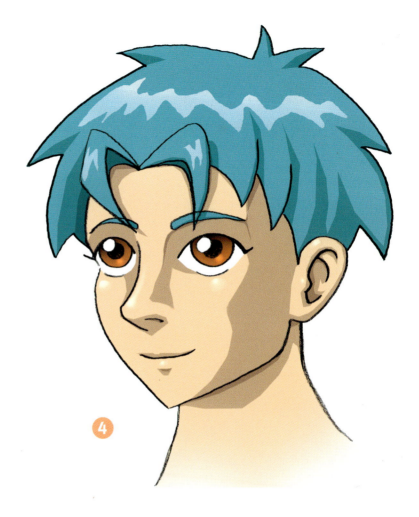

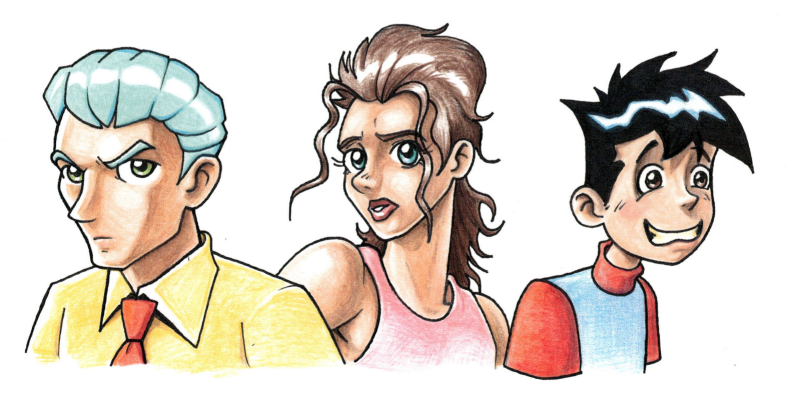

expressing Emotions

Manga characters can express a wide range of emotions. Is your character happy-go-lucky? Out for revenge? About to be obliterated by a giant raging robot? Then his or her face should show it. Here are some of the more common and manga-specific emotions. Try using a mirror and your own face to get the expressions you want.

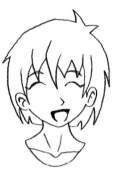

Pleased
Eyes closed in delight, high eyebrows and a smirking lopsided grin.

Laughing
Closed eyes, high eyebrows and an open mouth.

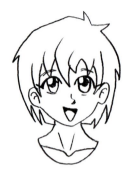

Happy
Bigger eyes with large highlights, high eyebrows and a triangle-shaped open mouth.

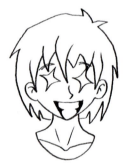

Joyous
Sparkling eyes and a huge smile. If the sparkles were replaced with dollar (or yen) signs, then the entire meaning of the expression would change.

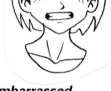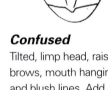

Embarrassed
Slanted eyes and eyebrows, teeth clenched apologetically and blush lines. A sweat drop is a dead giveaway that a character is embarrassed or stressed. The larger the drop, the more intense the emotion.

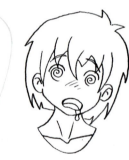

Confused
Tilted, limp head, raised eyebrows, mouth hanging open and blush lines. Add a stream of drool and spiral eyes for extremely confused characters.

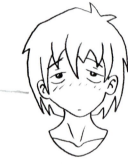

Sleepy
Slanted eyes and eyebrows (showing the effort of keeping the eyes open), blush lines and undereye bags. A noseless face brings attention to the tiny mouth and exhausted eyes.

Pearly Whites
Showing teeth in Japanese culture is considered impolite and even ugly. Historically in Japan, teeth were often covered with a black paste to make them invisible. It is still considered polite to hide your mouth when you laugh or giggle. Young manga characters often show teeth to express their youthful ignorance or crassness. Show teeth in a smile only to reveal the tactless and careless nature of the character.

Sly
A lopsided grin, narrow eyes and scowling eyebrows.

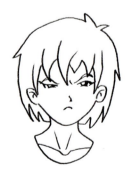

Pouting
Even narrower eyes; tight eyebrows with a single wrinkle between them, and a raised lower lip (a frown, of course!) that almost touches the nose.

Bored

Intense (but not angry) eyes and mouth turned slightly downward. The eyelids grow heavier as the character becomes more and more bored.

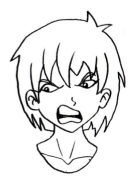

Annoyed

Extremely narrow eyes, arched eyebrows and a small, pursed mouth.

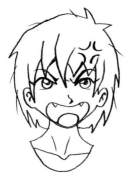

Angry

Small, intense eyes and mouth open on one side, muttering a complaint or rant. The eyes might stare at the offender in an almost disbelieving way.

Enraged

Wild eyes, highly arched eyebrows and loose hairs. Characters who are really at their wit's end may sprout fangs or have a raised vein (indicated by the star shape above the eye).

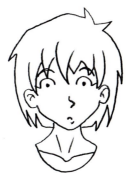

Shocked

Wide-open eyes with small pupils, arched eyebrows and an O-shaped mouth with an indication of a lower lip.

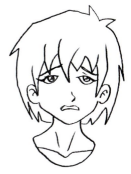

Terrified

Even wider eyes with small pupils and a mouth open wide with the top teeth showing. The character appears to be gasping or screaming.

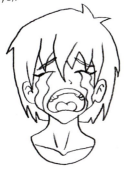

Worried

Eyes and eyebrows that rise in the middle, an open mouth wavy with uncertainty, and a worry line or two on the forehead.

Crying

Slanted eyebrows, streams of tears and a wide-open mouth with the bottoms of the top teeth exposed as the head is thrown back in agony or despair.

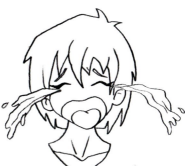

Bawling

Mouth open wider, eyebrows slanted even more and fountains of tears leaping from the eyes.

Blubbering

Eyes squeezing out tears, a flushed face and an open, frowning mouth revealing clenched teeth. The character is trying very hard not to cry, but she can't help it.

Yawning

An O-shaped mouth revealing the tongue and both sets of teeth; blush lines, very high eyebrows and tiny tears escaping from heavy eyelids.

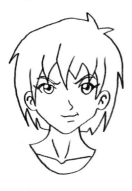

Smug

Wide and challenging eyes topped with angry eyebrows, and a haughty smirk dimpled to one side.

standard Proportions

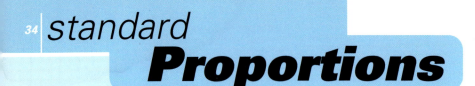

The easiest way to learn to draw the human figure is to understand the relationships between one body part and another. Proportions are really about how every part of a figure relates to the next part, such as how many heads tall a figure is. Manga proportions are inspired by realistic proportions, but are exaggerated, just like the other features.

Here are standard guidelines to help make your characters appear consistent and well-proportioned. Sometimes you will want to draw your characters intentionally out of proportion to enhance a physical trait for dramatic or comic reasons. Modify these rules to suit your characters.

The eyes are usually smaller and less expressive, suggesting experience and maturity.

Adults range from 7 to 8 heads tall.

The width of the shoulders is roughly 2 head heights.

Males have a bulkier upper torso than women.

The hands are about the size of the face from chin to eyebrows.

The waist is roughly 2 head widths.

Male hips are as wide as the ribcage.

Legs and feet should take up half of the total body height.

The neck is about ¼ of the head's height.

Female hips are slightly wider and start somewhat higher on the figure.

The wrists should begin at the halfway mark of the figure.

Adults

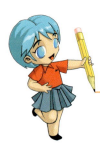

Meet You Halfway

When drawing a figure, it's a good idea to indicate the halfway point of the figure first, and then it will be easier to see what needs to go where.

Eyes range from wide to narrow depending on the character's personality and expression.

Teens range from 7 to 7½ heads tall.

Narrow eyes indicate cunning, maturity or exhaustion.

Large eyes suggest youth and innocence.

The neck is about ¼ of the head's height.

The width of the shoulders is roughly 1½ to 2 head heights. They are often more narrow and rounded than the adults'.

The build of the torso and musculature is toned down and less square than the adults'.

The wrists should begin at the halfway mark of the figure.

The hips are usually just as wide as the adults', but make them more fluid and expressive.

Large hands and feet add a sense of gawkiness.

Teens

Model Sheets

Draw the proportions of the main characters in your manga on a model sheet showing the character from the front, the profile and the three-quarters view. This will help you draw recurring characters consistently.

Most children are 4½ to 5 heads tall, but their proportions change dramatically as they age.

Children don't have muscle definition. Keep the features masked with a little bit of baby fat.

Hands come straight out of the arm and bend in a rubbery way (no narrow, bony wrists).

Hands and feet seem extra-large because although the head is larger, these features are still roughly based on the proportions of the face.

The eyes are usually huge. Small-eyed children appear to be up to something or are ill.

The neck is thin and is about ¼ of the head's height.

To emphasize their small bodies and large heads, the shoulders are often as wide as 1 head length or smaller.

The halfway point is at the waist instead of where the legs begin. This can make children appear off-balance and unsure when performing actions.

Children

Chibis are generally 2½ to 3 heads tall.

Chibis can represent toddlers or super-deformed versions of regular characters.

Eyes take up ⅓ of the head.

Faces and features are chubby and babylike.

The head, feet and hands are monstrously huge.

With arms raised and really stretched, a chibi's chubby fingers would just barely touch the top of its head.

An SD figure is a chibi with more extreme proportions.

The SD figure is 2 heads tall.

The eyes take up no less than ⅓ of the head.

The nose is usually replaced with blush lines or does not appear at all.

The body is small with limited detail.

Hands are small with sausage fingers or no fingers at all.

The shoulders are no wider than the head.

Feet are usually simple shapes that taper off the ends of the legs.

The Chibi

Super-Deformed

don't just Stand There!

It isn't enough to draw your characters standing still. Manga characters are full of action, even if they're just strolling down the street. Manga poses can be very understated, but even simple conversations between characters should show you something about their personalities.

Show, don't tell. Avoid the "talking head" syndrome that beginner manga artists often fall into. Body language can say much more than mere words can. The result is a character with even more personality than words can express.

Instead of showing your character simply talking like this…

…show her rubbing the back of her head or twirling her hair. This might show she is distracted or nervous in her current situation.

Instead of having your Big Bad explain his evil scheme while just standing there…

…have him really get into his speech and gesture wildly. Tilting him to one side makes the figure appear unbalanced and full of tension.

Who Are You Looking At?

Try using a mirror and your own face to get the expressions you want.

Shounen characters often have very intense and exaggerated body language. This guy appears to be getting ready for a showdown. He's not too happy about it. Maybe he was taken by surprise.

This character seems to be preparing himself for the battle to come. His stance is solid and certain. It looks like he's taking a solemn vow.

This bishounen swordsman appears to be the strong, sensitive type. Notice how the wind gently sweeps through his hair and his wrist bandages.

Shoujo character poses can range from wacky to dreamy. This girl looks like she's dreaming of her hunky boyfriend.

Foreshortening

To make poses and action even more dramatic and exciting, try using foreshortening. Foreshortening is a perspective technique that makes objects appear to be coming out at the viewer. Things that are closer appear to be larger, and things that are smaller seem to be farther away.

This punch isn't very exciting when seen from the side.

This man is speeding toward us. Extreme fore-shortening hides parts of the figure. The tops of his shoulders and his head hide his chest and stomach completely. His right leg is lifted and his foot is hidden behind his thigh. The cloud of dust behind him leaves no doubt that he's running very fast.

POW! When seen from the point of view of the person being punched, the pose is much more dramatic.

drawing
Hands

One of the hardest things about drawing the figure is what to do with the hands. Some beginning artists will do anything to avoid drawing hands; they'll draw all the characters with their hands in their pockets, behind their backs, or hidden by clothing. The reality is that hands are no harder to draw than anything else. Just break down the hand to the basic shapes and you will be able to draw hands doing anything.

You want the hands to be expressive and help make the figure appear more realistic. Keep a reference file of pictures and drawings of hands in various different poses, taken from magazines and manga. Look at how people stand while waiting for the bus or in line. Make some notes or sketches to help you when you draw your own characters.

The length of the longest finger is roughly the same size as the palm.

Hands start with basic shapes.

Practice drawing your own hand from many different angles. Pick up something and draw your hand holding it. Fill pages of your sketchbook with hundreds of hands.

drawing
Feet

Just like hands, many artists do whatever they can to avoid drawing feet. Eventually you will have to draw a foot or two. Approach the foot like any other part of the figure. Break down the forms into simple shapes and then add details of the foot to make it more convincing.

Make sure the footwear your characters are wearing fits with the type of story you are telling. Fantasy characters in medieval Japan rarely wore sneakers. Do not be afraid to do your research. Catalogs and magazines are great resources for images of footwear. Practice drawing feet whenever you can and keep a reference file in a sketchbook or portfolio so that you can use it when you need to.

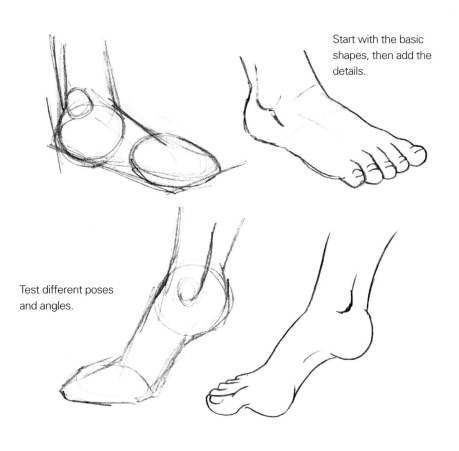

Start with the basic shapes, then add the details.

Test different poses and angles.

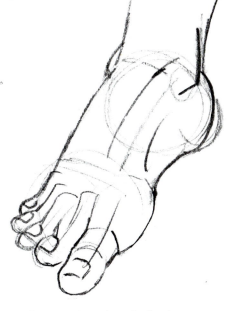

Pay attention to how the foot's appearance changes once slipped into an open shoe.

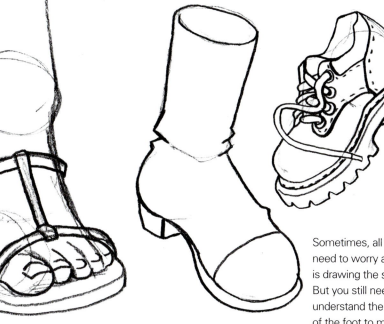

Sometimes, all you need to worry about is drawing the shoe! But you still need to understand the shape of the foot to make sure the shoe fits.

clothing and Accessories

When drawing clothing, first choose an outfit that suits your character. Consider the practicality of the outfit. Does it make sense for a professional baseball player to wear a pair of jeans and platform shoes when he's up to bat?

Accessories such as jewelry can provide little clues to the personality, age and tastes of the character you are drawing. A cute and innocent schoolgirl wearing dangly skull earrings might appear more threatening than if she had bunny earrings.

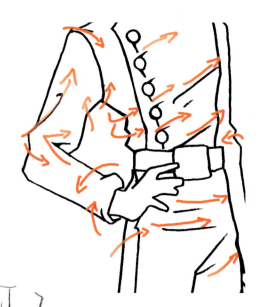

Clothing folds in specific ways and should never look flat on the figure. Let the clothing help to define the 3-D form of the figure by creating lines that move across the figure as wrinkles.

Pay special attention to the details that make the clothing easily identifiable. Jeans, for example, have stitching along the side of the leg and have a zippered fly, pockets and belt loops.

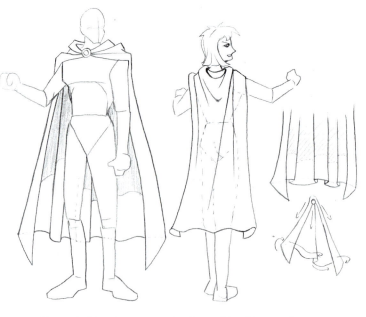

Some clothing drapes over the figure. Use this as a chance to draw the effects of gravity. The cape or dress should reveal some figure details and conceal others. Flip through magazines or catalogs and look at the models to see how different clothes fall over the body and to help you accurately draw folds and creases.

Play Around

Toys and action figures can help artists with poses and costume details. Some artists even use action figures to work out complicated lighting effects. It's much easier to move a toy around than to dress up your friends and family to pose as models. It's also a good excuse to buy new toys!

manga-specific
Clothing

Every storyline has common clothing types that can be identified. Japanese school uniforms appear in many manga because school-aged readers make up a large segment of the manga market. Both elementary and high school students wear uniforms, even for weekend school activities. There is no standard uniform across the country, but they are fairly similar from school to school.

Stories set in old-time Japan often deal with ninja and samurai action. Go to the library and do some research to get the details right on complex clothing like samurai armor and kimonos.

Girls' uniforms vary from the familiar "sailor suit" to the increasingly popular skirt-and-blazer combination. Many girls wear very baggy socks. Accessories such as hair clips, purses and school bags are often decorated with cute cartoon characters.

Boys' uniforms consist of dark pants and blazers. Some schools require students to wear matching caps. Despite the similarity of uniforms, individuals still manage to express their personality in small ways by rolling up their sleeves or keeping the top button of the white shirt unbuttoned.

mischievous **Chibi**

Chibis are used for comic relief, balancing the action and drama with a wacky, super-deformed (SD) version of a character running around in a youthful, carefree way. Chibis often cause all kinds of mischief, violence and property damage, which usually disappears when the characters return to normal from their SD forms.

Use chibis to break up tense situations or when the story is taking itself too seriously. They should be silly and off-the-wall, doing ridiculous things. Let them run up the sides of buildings, heave tanks and haul giant hammers out of the air to flatten their opponents. Just remember, nothing that happens in chibi form should really alter or change the course of the story.

1 Roughly place the main body segments plus the shoulders, hands, knees and feet. Use the chibi proportions of 3 heads tall. Some chibis are pudgy and babylike; others are long and lean. Make the proportions suit the character. Draw the eye line and vertical axis on the face, turned slightly right.

2 This chibi is happy (wide eyes) but ready to cause some mayhem (arched brows and blush lines). The eye on the left is just a bit larger than the other, since his head is only slightly turned. If turned more, the difference in size would be bigger. Lightly flesh out the arms, position the hips and give him some pants. This little guy looks like he's surfing. If his body language isn't working, change it now before moving on.

3 Start using heavier lines. Wild, unruly hair gives him some personality. Make sure the hair rises off the skull, but don't forget that gravity has some effect on manga

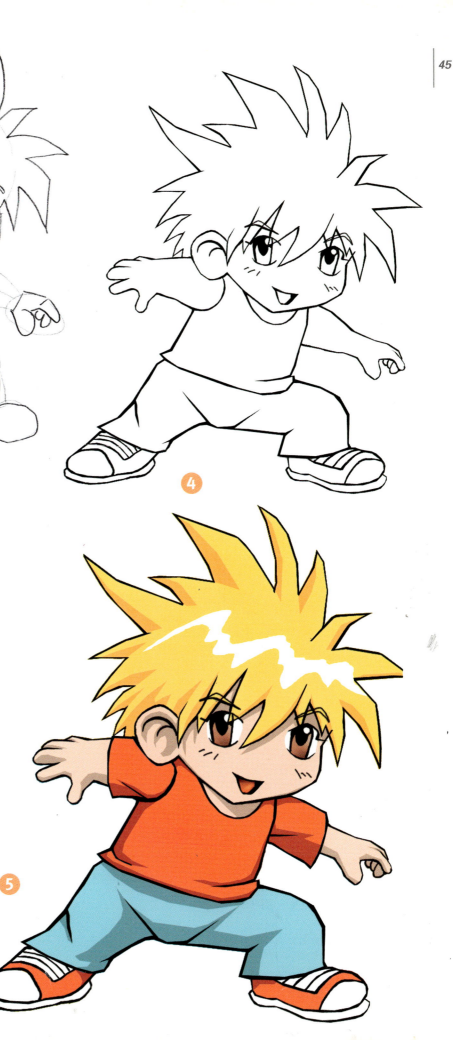

hair (just not too much). We see only one ear, and his hands are chubby. His torso, neck and hips are defined by the lines of his clothing. Avoid an amateurish, pasted-on look by drawing his clothes to fit around his basic form.

4 Erase the light guidelines and clean up the drawing. Your final lines should be solid and confident, not sketchy and timid. Trace over your rough drawing with a clean sheet if you want to. Flesh out the arms and leave highlights for the eyes. Make sure his clothing has folds and creases, so he's truly wearing it. Add a pair of sneakers and he's ready to run from anyone who tries to stop his fun.

5 With some shading and color, this guy's ready to go. I changed his tank top to a sleeved T-shirt because I wanted his head to contrast or stand out against the red sleeves. You decide how far to take the details. Don't forget the highlights on his hair.

dashing Hero

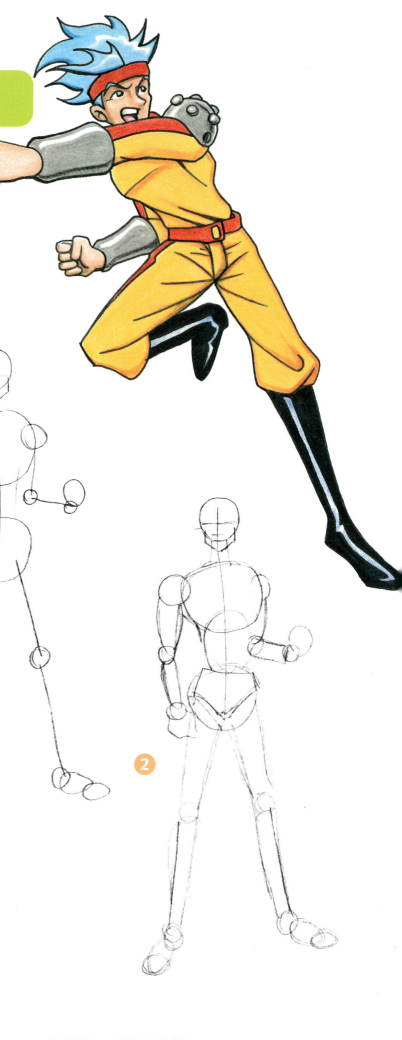

The Dashing Hero is young, confident and looking to take revenge on the Big Bad (his arch rival) or to right some wrong. He is usually on his very first adventure and almost always falls in love with a woman from the "dark side." Their love could be tragic, or it might be exactly what's needed to stop the two sides from fighting each other.

1 This hero will have a strong stance: feet firmly planted, posture strong, one fist clenched. Make sure the feet are balancing his weight well and that his proportions are correct (8 heads tall). Draw the jaw, eye line and vertical axis on the face so that he's looking at you head-on.

2 Add some muscle mass to his arms and legs. Don't draw him bulky; our hero is fit and trim. His hips should be narrower than his chest. Add a neck and nose line and he's starting to look human. Adjust the position of his left foot so it doesn't jut out to the side so much. The hand at his side starts to take shape.

3 Start erasing the skeletal lines and strengthening the basic outlines. A dramatically raised eyebrow hints that this guy is on a mission. His messy hair is held up off of his head (and out of his way!) with a headband.

4 Finish erasing the light guidelines and dress him in a costume. I've drawn him wearing his giant-robot pilot jumpsuit. He has

Take It Easy!

Make the main character in your story easy and fun to draw. You will be drawing that character on nearly every page and panel of your comic.

big, shiny boots (highlights down the center) and protection for his forearms and shoulders. Lines and creases show not only how his clothing fits but how buff his physique is. Refer to your own fists to draw his.

5 A jumpsuit in bright yellow and red makes this character really stand out from the crowd. Blue hair and green eyes give him an exotic, cool look. Pay attention to where the light source is located (here, the front right) when you are shading and placing highlights to give him 3-D form. Shadows should follow folds and creases on clothing; the hand at his left side casts a shadow on his leg; the deep shadow down the left of his torso defines his muscular form.

magical
Girl

The Magical Girl is usually a popular but somewhat ditzy girl in middle school or high school who has lots of embarrassing problems. Somehow she is the heir of special powers and abilities that are triggered through a magical item.

Costume details are very important for Magical Girls. The costume should be elaborate and unusual, but have a playful, feminine appeal. Some Magical Girls get a makeover every time they transform to their heroic selves. The details of the costume can be an interesting sidebar to the main story.

1 This preteen is about 6 heads tall and tilts her head in a three-quarters view. Make sure her skull is bigger in the back or she'll look like the back of her head was cut off. Try a strong stance: legs and feet together, head centered over the base of her feet for balance. Her raised hands are positioned to cradle her scepter, the source of her magical powers. The arm closer to us will look slightly bigger.

2 The arm on our right covers her torso, but lightly draw the covered part anyway; you can erase it later. If you don't know what's going on beneath the arm, you might get unwanted figure distortions. Sketch her costume details. Her power of flight will come from magic mechanical wings. Clunky shoes give her a sense of gawkiness, as if she hasn't quite grown into her role. She's young and innocent, so make her eyes huge. Her fingers gesture playfully, making the scepter seem lightweight.

3 Start cleaning up the details. Her short hair reflects her perky personality. If a Magical Girl's hair is longer, it's usually in ponytails or braids. Her dress mirrors her wings, and her winged headband tops off her aerodynamic look.

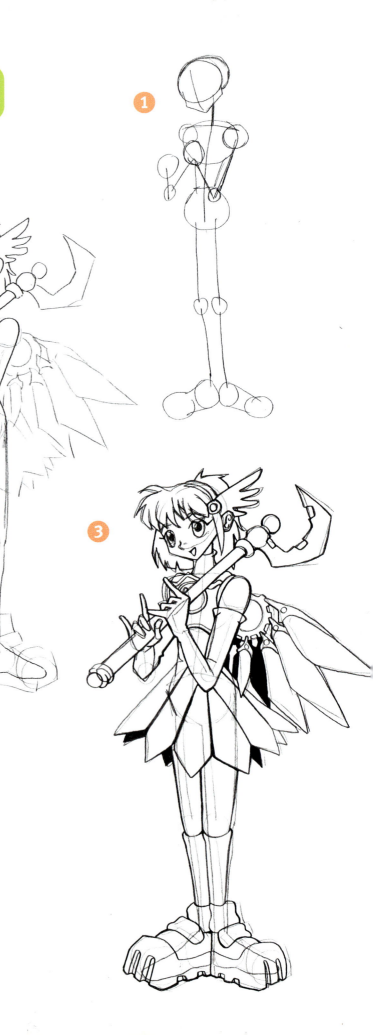

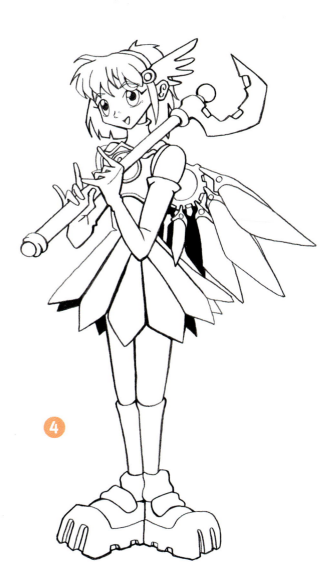

4

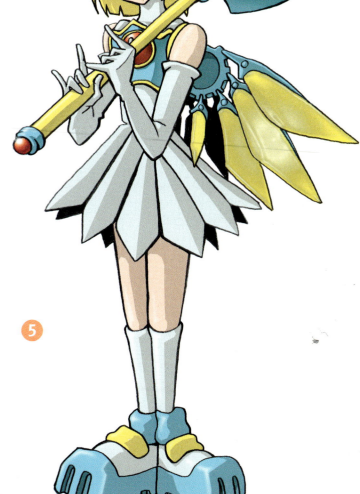

5

4 Erase the remaining guidelines or trace the figure on a clean sheet. Alternately, you may ink the figure with a pen at this stage. Be sure that the ink is totally dry before you erase the pencil lines or else you will have a smudge on your hands.

5 Color choices are very important and symbolic for the Magical Girl. In this case, she is blonde and blue-eyed to show innocence and purity. Her costume is predominantly blue, a color representing spirituality and the otherworldly. Her scythelike scepter is decorated with two rubies and she has similar gems on her chest and headdress. She's ready to fly!

What Every Magical Girl Needs

- A cute animal mentor or sidekick who can identify the bad guys.
- A team of friends who assist her in the battle against evil.
- Mysterious allies who help, then melt into the shadows.
- The ability to transform from a mild-mannered girl into a magical warrior. To transform, she needs to utter special words or use special items.
- Magical powers triggered by catchy names like "Gold wing feather blast!" or "Cosmic love power strike!"
- Elaborate, ever-changing costumes.
- An unattainable love interest who doesn't notice the normal girl, but is interested in the Magical Girl.
- A long history that links her to a mythical past that has been hidden or forgotten. She often has a royal connection; she may be the princess of a forgotten kingdom.
- A familiar setting such as a school where the character's innocent past conflicts with the new responsibilities of magical power.

rebellious
Hero

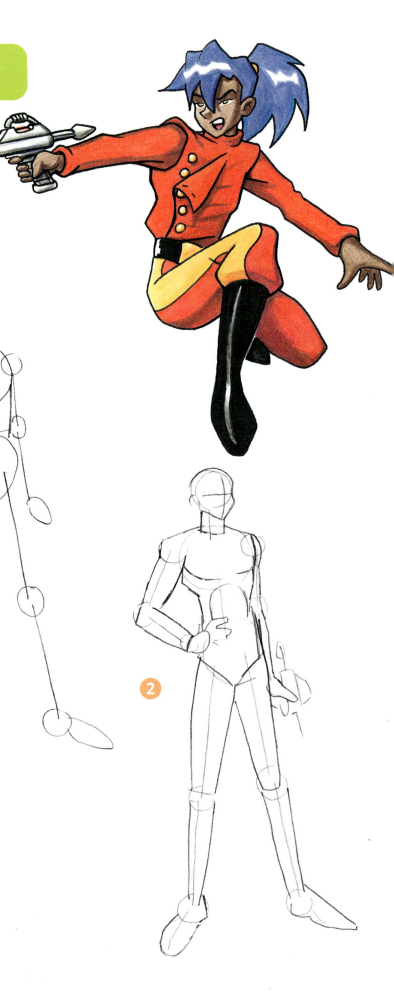

The Rebellious Hero is the shadow side of the Dashing Hero. Usually just as strong and capable, the Rebellious Hero lacks the discipline and control of the Dashing Hero. Strong and powerful emotions cloud his judgment and cause him to act rashly, putting everyone at risk.

Often the most powerful character in the group, the Rebellious Hero lacks the cool-headed charisma to be a leader. He is constantly frustrated with his role in the group and is prone to royal temper tantrums if his brilliant ideas are shot down by the Dashing Hero. He often makes a deal with the dark side that threatens the whole group, but provides valuable insider information about the bad guys. This betrayal must be repaid with his life or some form of redemption, such as admitting he's wrong or rescuing the Dashing Hero during the climactic struggle.

1 Notice how the weight of this character is placed on the left leg. At first the character seems ready to react, but is distant or withdrawn, standing apart from the action. The character is somewhat off balance. When standing slightly off center, the character appears sleeker and more catlike. The hand on the hip suggests attitude and a slight superiority complex.

2 Avoid making the character overly muscular. He should appear somewhat stronger than the Dashing Hero, but more sophisticated. Even his gear and weaponry should appear refined and sleek.

3 Both the character's attitude and personality are revealed in the pointy chin (a sly, foxlike feature) and narrow eyes (less innocent). The weapon design echoes the sleek lines of its owner.

4 Fix the anatomy to maintain both proper proportions and the sleek look, and develop his old-fashioned uniform. The personality of the character is totally developed by this stage. His stance is impractical, but adds to the smug air of superiority his sneering face seems to express.

5 I chose to make his costume red with gold accents because it is the opposite of the Dashing Hero's yellow color scheme. In Asia, red signifies luck and celebration while yellow is the color of imperial sacredness. The color choice makes the Dashing Hero seem purer than the Rebellious Hero.

Rebel, Rebel...

Many Web site shrines have been dedicated to these lovable, yet doomed antiheroes. The Rebel's appeal lies in his world-weary confidence and street sense as well as his refined, elegant appearance and fashion sense. The Rebel is free to act outside of the rules and that makes him more dangerous and interesting. The dark side of the Rebellious Hero creates more conflict and inner turmoil than the Dashing Hero, who is often a victim of fate. The sacrifices of the Rebellious Hero create unforgettable drama and add an unpredictable reality to the manga.

the Kid
(shounen)

Hundreds of manga stories have been devoted to the courageous boy who befriends the giant monster, pilots the robot armor or sets off on a heroic quest to save the kingdom. Shounen comics are all about overcoming obstacles and achieving personal bests. Even older readers respond to manga about children because they once had to go through the same things as the characters. Nostalgia for times past and the innocence of youth is a common theme in anime and manga.

The kid can be a younger brother to the hero or simply a tagalong for the adventure. Often the kid operates in a group where he's treated like a mascot and must constantly try to prove himself worthy of adventuring with the older characters.

1 Children are normally 4½ heads tall and have slightly larger heads than adults. Keep the neck thin and no more than one-fourth of the head's height. Don't forget to draw the back of the skull when drawing a three-quarters view. Notice how the feet point out like a "V" in a three-quarters view. Keep one foot higher than the other, grounding the character in the picture plane.

2 Keep the body cylindrical and avoid drawing obvious muscle details. The character should still have some baby fat on him. Keep things fairly soft and rounded. The body language is positive and sort of silly at the same time. The gestures are awkward and exaggerated.

3 Manga kids have wild hair with lots of cowlicks and spikes. Pay attention to the folds and wrinkles of the clothing. Think 3-D by drawing arm holes, the neck hole and jeans cuffs. Lines indicating his pockets

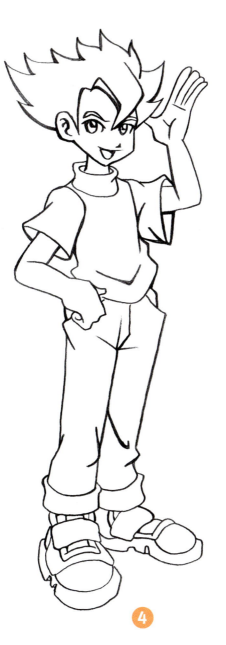

3

4

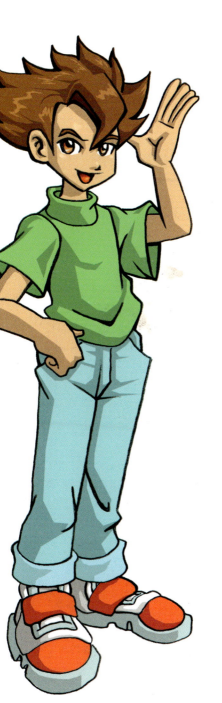

5

and knees should jut outside the main lines of the pants. Erase some of the rough construction lines as you work.

4 Control the weight and pressure of your lines. Darker, thicker lines appear weightier; use them for areas of shadow or emphasis. Outlining the figure with only heavy lines flattens the image. Alternating thick and thin lines give the drawing a stronger sense of 3-D form.

5 When you begin shading, the most obvious clue about where the light is coming from is found in the eyes. Look for where you put the highlight. That will be the side of the figure that the light falls on. Add a few more details such as wrinkles and hair texture as you add color.

Boy's Day!

May 5 is Children's Day in Japan, but the main focus of the day is a festival celebrating boys. Carp windsocks decorate rooftops, one for each boy in the family. The carp is a symbol of power and resourcefulness in Japan because it battles the rivers and streams to travel upriver. May 5 reminds Japanese boys that they can overcome any obstacle they encounter to become successful and capable men.

Girls
(shoujo)

Girls are the lead characters in most shoujo manga, but they play an important part in many shounen manga, too. The girl is often a younger sibling of an older lead character. If the girl is the focus of the story, she may even have a younger sibling who provides comic relief and who might need rescuing from time to time. Girl characters usually develop from mundane surroundings and become strong, capable adventurers.

1 This kneeling position is a very difficult pose. Many details are hidden by the overlapping arms and legs. At this stage you should know where everything goes. Don't be afraid to draw what is hidden by other body parts. Keep the lines light and darken the proper outlines that are not hidden by other body parts.

2 Don't make her too lean. Children still have some baby fat, so think of their arms and legs as plump sausages. Keep things rounded and avoid sharp angles. Think of the figure as a series of interconnected cylinders and spheres. Note that the hand closer to you is lower than the other, and fanned out like a pie slice so that all the fingers won't look the same size. Things that are closer to you overlap and hide things that are farther away.

3 Work on details of the anatomy, face and hair. This is the stage where you should dig through your resources or imagination to come up with some ideas for hair styles and clothing. A bouncy ponytail is perfect for this little lady. Clean up any extra lines that might be cluttering up your drawing.

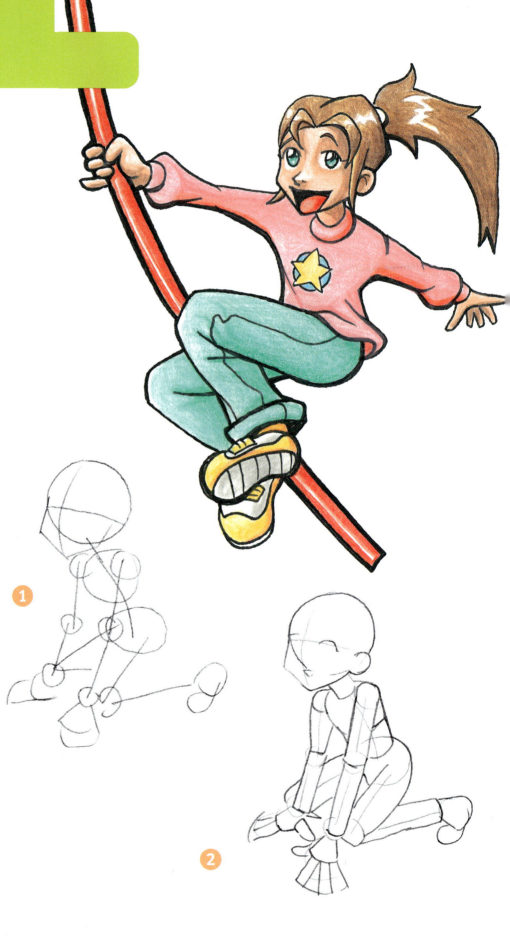

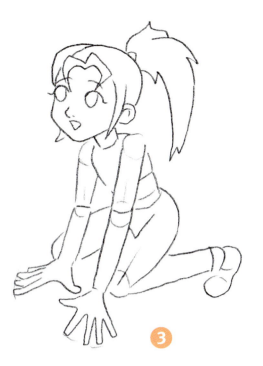

3

4 This outfit is both realistic and contemporary without being too specific. Make sure that the folds give the impression of a rounded form existing in 3-D space. Consider the folds as lines that wrap around the arms, legs and torso. Revealing the bends and shapes with wrinkles and folds makes the drawing more convincing. Two tiny nostrils and a small check are enough to indicate the upward tilt of her nose.

5 Keep the colors fun and light. Details such as the star shirt may provide symbolic clues about the role of the character in the story or could simply be for decoration and fashion.

4

5

Girl's Day!

March 3 is a doll festival and a peach blossom festival in Japan. It is a day set aside to honor the feminine traits of refinement, serenity and self-control. Houses are decorated with elaborate doll displays and peach blossoms.

the **Big Guy**

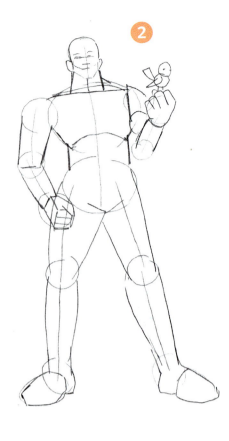

The Big Guy is a lovable lug, a two-fisted bruiser with a heart of gold. At first glance he appears fierce and powerful, but he has a weakness for food, cute animals or pretty ladies. He's often a simple peasant with superhuman strength. He is usually the largest of the group and, being an obvious target, is often the first to fall. He is a loyal friend to the Dashing Hero and often takes care to nurture the Kid when he can. He may primp and preen when the Magical Girl passes by, but blushes and stutters when she confronts him.

The Big Guy is the heart and soul of the team, not just the mindless muscle. He might be the computer expert or chemist of the group. You can't always judge a book by its cover.

1 You can really go nuts with the proportions when you want to. The chest circle in this gesture study is huge. Everything has been supersized except the head. Keeping the head smaller gives a sense of bulk and power to the figure. Notice the slight twist of the hips and shoulder. Most of the figure's weight is placed on the leg on our left.

2 Make the neck huge. Be aware how it arcs out from below the ears and slopes down to the shoulders. The figure should be big and strong, but not a muscular powerhouse. The tiny bird was added with simple shapes. Adding details like this makes the character more sympathetic.

3 Block in basic costume features. Elements such as the details of the nose, cheekbone and jaw help define his character. He's larger and physically stronger than the others. To draw his fists, just treat them like boxes at the end of his wrists. I usually start by drawing the back of the hand as a rectangle in perspective, then add the thumb and fingers.

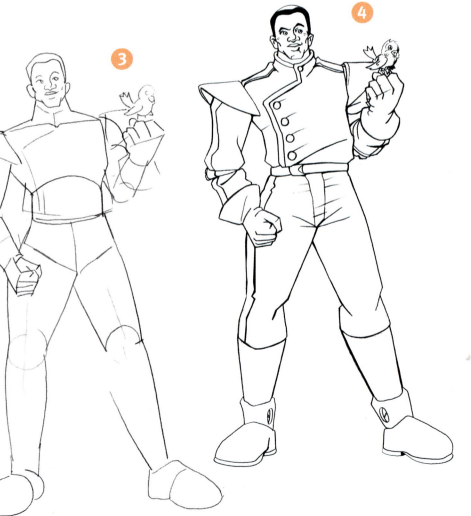

4 This costume gives him a very militaristic or policelike appearance. The shoulder pads make him look even bigger. The clothing folds and creases help define the figure and the points of tension in the costume. The buttons, for example, seem to be pulling on the front of his shirt. Wrinkles appear where clothing is overlapping or responding to being pulled. Draw the bird as cute as possible to take the edge off the clenched fist.

5 The final shading and coloring should add detail and information about the clothing. Don't just color in your drawing like a picture in a coloring book; reveal the 3-D form of the character and make it come to life. Instead of straight lines, the wrinkles should be curved to define the figure underneath.

A Five-Star Lineup

The Big Guy rounds out the classic structure of the "five warrior" team, which is found in many manga, anime and live-action sentai shows. Even the popular *Star Wars* films have used this team structure with much success. The Dashing Hero often joins with the Big Guy, the Princess and the Kid to fight evil. The Rebellious Hero joins the fight reluctantly, arguing with the Dashing Hero. Sometimes the Big Guy and the Rebellious Hero are a team, with the Big Guy providing a sentimental balance to the hard-hearted rebel. There is usually a strong connection between the Kid and the Big Guy.

| # *the* **Mascot**

Where would the mighty hero be without the lovable Mascot? The Mascot can be a pet or alien creature, or even a mechanical being. Either way, the Mascot should provide endless amusement and trouble for the heroes. It is the Mascot who reveals their hiding place by sneezing, breaks the computer or embarrasses the team at the most untimely moments.

The most common form of the Mascot is a strange hybrid of cat and rabbit known as the "cabbit." Any other animal features are fair game to throw into the mix, such as fox tails, bat wings and antennae. The Mascot usually has one standard catchphrase or sound that it repeats over and over again. It's a good thing it's cute!

1 Keep things loose and round at this stage. The Mascot should be simple and cute. Use the chibi or child proportions if the figure walks around on two legs like this one. The Mascot can do anything you want it to do; just keep the figure 3 to 4 heads tall.

2 Add some paws with claws, a large tail, fangs, pointy ears and the start of a hairy face, and your Mascot becomes a cat. Make the toes closest to you biggest and the rest smaller. Even though the Mascot is a little more cartoony and simplified, it should still look 3-D. Its huge feet are perfect for pouncing.

3 Develop a catlike character with details like fur and claws. The tail is big and fluffy like a fox's. This Mascot has been drawn without a nose because it distracted attention from the large mouth and expressive eyes. In a story, details can change as the character changes gestures or attitudes. The potbelly can all but disappear in the next drawing if it suits the situation.

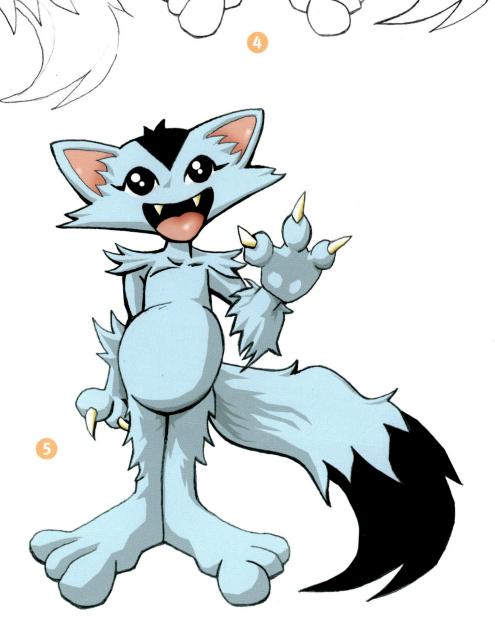

4 Clean up the lines and finalize the details such as the ears, eyes, mouth and hair-growth patterns. The friendly gesture, beaming smile and the fact that it is standing like a person let you know this is more than just a pet—this creature has an important role to play in the story. Keep the Mascot fun and cute.

5 The most striking thing about this creature is the fact that it's blue. Blue is not a natural hair color, but it is everywhere in manga. Blue fur makes the Mascot appear more exotic and alien. You can be sure that the Dashing Hero spends more time picking clumps of blue fur out of his spaceship air vents than he'd like to admit!

fallen Hero

Nothing is more tragic than the Fallen Hero. Trained and conditioned to be the best defense against the forces of darkness, the Fallen Hero is somehow corrupted and twisted into an agent of evil. There is usually some sort of connection with one of the main heroes of the story. The Fallen Hero might be the twin brother of the Dashing Hero or an ex-boyfriend of the Magical Girl.

1 The gesture study should have a strong, powerful stance. Keep the arms closed and the head dropped down a bit. He should be confident and cocky enough to frustrate the heroes into attacking first. Keep the figure proportions similar to the Dashing Hero or Rebellious Hero. The Fallen Hero should resemble a twisted funhouse-mirror version of those characters.

2 Loosely block in the hair and clothing. Remember that the arms and legs should be cylindrical, not flat. Draw the clothing as it would wrap around 3-D forms. Add a partially concealed sword on his back. Swords and duels are important in manga, even in science-fiction stories. Swords let the bad guys get up close and personal in their struggle with the heroes. Even giant robots are often armed with giant swords and shields.

3 Give the Fallen Hero attitude with body language and facial expression. Crossed arms indicate an unwillingness to listen and defensiveness. A sideways glance of his narrow eyes, his raised eyebrows and an evil smirk suggest that he's up to something. He obviously knows something that the heroes don't.

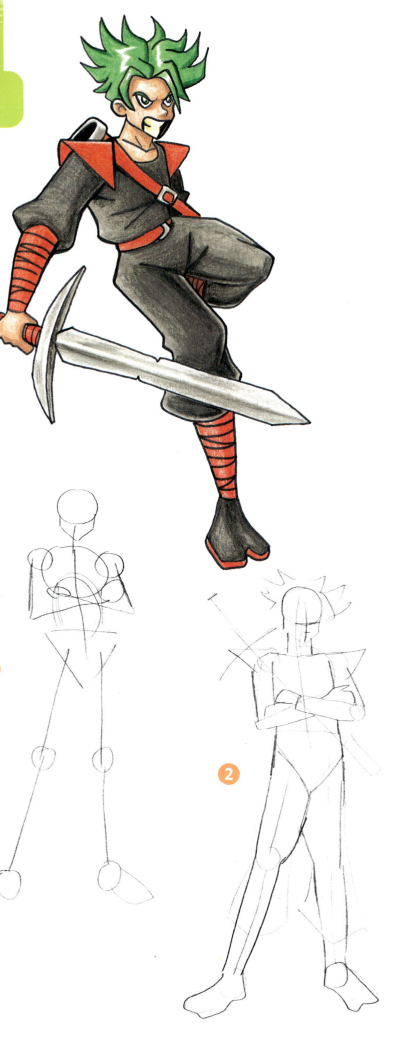

4 Carefully erase the guidelines and ink the image or trace it onto new paper. Pay close attention to details such as the tabi boots (used by ninja), buckles and weapons. A strap across his torso holds the sword to his back. Attention to details helps convince viewers that what they are seeing is real.

5 Unless the Fallen Hero has a totally showy personality, dress him in fairly dark colors. This dark gray-and-red combination makes the character seem more sinister and emphasizes his gloomy nature. Highlights are especially important on darker clothing to make it look 3-D. Remember to keep your light source the same over the entire figure, and use the eye highlight as your guide to light direction.

The Guys You Love to Hate

The basic plot of any work of fiction involves some sort of conflict. A good villain makes a story memorable, even if it's just a strict teacher in a shoujo manga. Don't make your bad guys snarling stereotypes; get into their heads and make them interesting. Give them quirks and flaws to make them human. Above all, avoid making them look stupid. Nothing adds to the drama more than a smart enemy. Keep the villains one step ahead of the heroes and the readers will be caught up in the suspense. The race to the end to see who will win should be unforgettable.

evil Queen

The Evil Queen appears in many shoujo manga. She barks orders to her unlucky servants who scramble desperately to satisfy her every whim, including destroying the heroes. Fortunately for the heroes, they always fail and have to face her wrath.

Often times the Evil Queen is after an item of magical power possessed by one of the heroes. This item would give her the power she needs to take over the universe. She is usually unable to directly affect the world; that's why she relies on her followers to do her dirty work. She possesses powerful magical skills and can foretell future events. Despite her power and grand plans, the heroes always save the day, often in a symbolic victory of love over hate and sacrifice over selfishness.

1 Our queen should appear strong, confident and sneaky all at once. Even though you will eventually hide the legs with a long dress, sketch them now so you know what they're doing and to avoid making the figure too squat.

2 The dress should drape down off of her body. Long strips of material make her appear more octopuslike. Wild, flowing hair echoes the movement of the dress, and razor-sharp claws complete her otherworldly nature. The shape of her crown suggests horns.

3 Make some of the looser lines clean and crisp, and carefully erase the lighter gesture lines of her basic structure. Costume details such as the belt, necklace and the headdress should echo each other, creating unity. Make it clear that she puts some thought into her wardrobe before she sets off to conquer the universe.

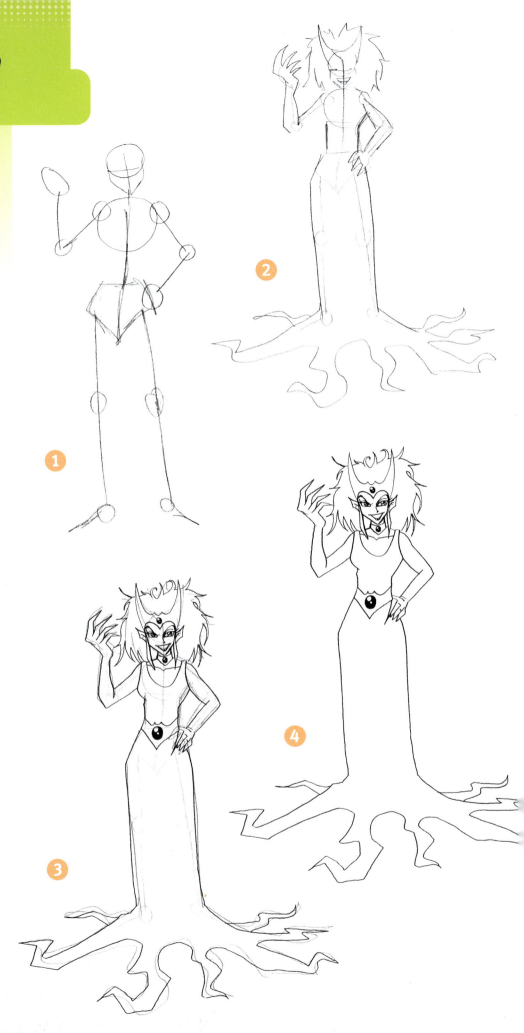

Out of Character

As you are discovering, manga has a wide range of character types. The Evil Queen may show up in the form of the wicked stepmother, the bad fairy or the scary witch. We expect these characters to play their roles as they have countless times. If the Dashing Hero always behaves in one way and the Magical Girl in another, the story is easy to follow, but predictable.

Recognizing these character patterns is an important step to creating original, dynamic stories. By manipulating these patterns and changing the expectations of the reader, we can shock them into seeing old ideas in new and unusual ways. Use character patterns to help develop your story idea. Then, as soon as you've hooked the readers, throw them a curve ball.

4 When cleaning up or making the final drawing, alternate soft, curving, feminine lines with sharp, dangerous angles. The ends of her dress should look like they are writhing like snakes or tentacles, and her hair should be big and wild. Details such as claws and fingerlike ears reinforce the fact that the Evil Queen is *not* human. Her narrow eyes and one raised eyebrow suggest that she toys with her enemies before she destroys them.

5 The most striking thing about the final image is the solid, dramatic black of her dress and her green skin and hair. The unusual skin color adds to her alien nature without making her totally inhuman. Her gemstones are black and blood red. She appears proud and noble, with a hand raised and ready to strike down her enemies.

the **Big Bad**

The Big Bad is the main opponent of the good guys, but he is rarely confronted until the last climactic battle. He is usually a leader who sends his underlings out to do his dirty work. He sometimes takes orders from a larger, more ominous force such as the Evil Queen or a mysterious creature of darkness.

The Big Bad usually has a very good reason for what he does. He doesn't believe he's evil; he's doing what he can to protect his interests or what he believes in. Make sure the Big Bad has a good motivation for his actions.

1 The Big Bad can be large and bulky or thin and lanky. The concept behind this Big Bad is "the general," so he'll have the best weapons and the best armor. Give him a solid, even-footed stance. He should be big enough to stand up to the combined force of the good guys if he must.

2 Block in the muscle mass. He should look solid, but not like a weightlifter (unless he *is* a weightlifter). The Dashing Hero should look rather scrawny compared to the Big Bad.

3 The Big Bad should have refined, aristocratic features. He is rarely a slobbering beast. The Big Bad prefers to sniff a rose and gloat about his superior intellect as he executes his big plan, instead of hooting and screaming insults. His hair is neat, his eyes beady, and his hand grips the largest of swords. The pattern on his armor is not too difficult. Try to make the pattern the same on both sides and don't get too elaborate or you'll never want to draw him again.

4 Details such as the armor pattern and the pointy treads on his boots reinforce the power, status and cruelty of the Big Bad. Details of the cape should be based on observation of real cloth and how it reacts to gravity and wind.

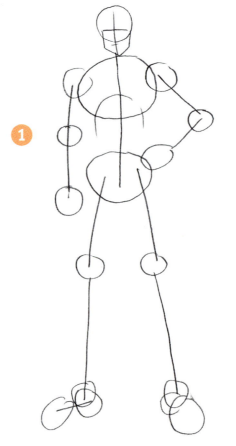

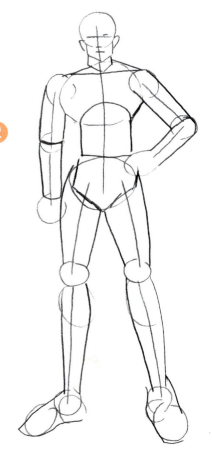

3

4

5 An unusual skin color makes the character appear somewhat alien. Notice his eyes are very different from standard manga eyes. He appears to be squinting or creasing his brow. Each iris and pupil is a tiny dot, and his eyes have an evil glow. The cape gives him a sense of majesty and great power. Coloring it red and making the details gold makes this Big Bad appear very regal indeed.

The Light in the Dark

The duality of all things—light and dark, good and evil—is an ever-present concept for humanity. Manga deals with the struggle of good and evil constantly. We are trained to cheer on the good guys and boo the bad guys. Manga realizes that all characters have a motivation. Within the darkest heart is a balance of light, and within the brightest soul is a touch of the dark side. Overcoming our frailties and confronting our shadows is a lifelong challenge. Growing up is about recognizing who we are, our strengths and our weaknesses. What a great thing to base a comic book on!

5

mindless Goons

Every Big Bad needs an army of Mindless Goons to boss around. They could be goblins, demons or clones. Mindless goons are usually heavily armed, armored and quite scary-looking. They are often dressed in a manner that conceals their individuality and makes them appear less human. They have impressive weapons but are horrible shots, and when they are hit they almost always fall down and stay down even though they may be wearing full combat armor.

1 Mindless Goons should be bulky and impressive. Keep the shapes loose at this stage and focus on the solid, massive forms of the armor. Notice that this workhorse has no neck, and it carries a big weapon.

2 This Goon is covered with protective armor from head to toe. Try to give costume details a purpose. You never know when you may need to know that information in a story. The tubes that rise out of the shoulder might hold coolant fluid, batteries, medicine or food supplies. You may want to try drawing the figure from several angles so that you can keep the details consistent as you draw the character.

3 Make sure that you keep your light source the same for every part of the figure as you are shading. Shadow should wrap around the figure. Highlights and texture add realism to the costume. The armor is scuffed and battle-scarred. The colors are muted so that the Goon does not draw the reader's attention from the Big Bad or the Dashing Hero.

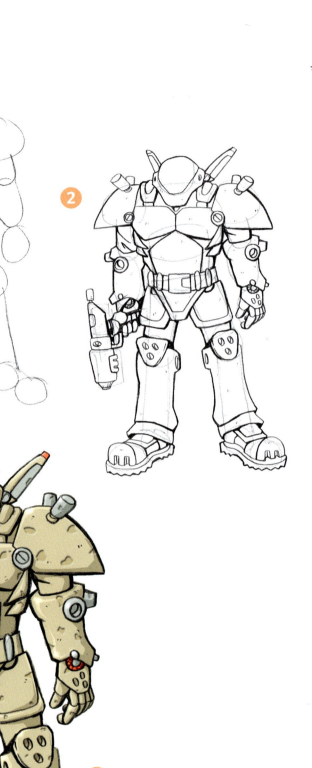

unstoppable
Fiend

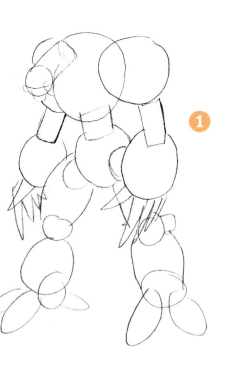

The Unstoppable Fiend is the secret weapon unleashed on the heroes by the Big Bad. Tougher than the Mindless Goons, the Unstoppable Fiend is a challenge for the entire team of heroes to defeat. The individual hero cannot defeat it on his own; it can be defeated only with teamwork and intelligence. In other genres it might be an ogre or a giant, or even the captain of the football team. The Unstoppable Fiend is a worthy opponent for the heroes to overcome.

1 Don't worry about sticking to proportions. This is a monster! Exaggerate the physical features that make him appear big and scary. Make the shoulders and claws huge. Make the neck as thick as its small head. Hunching the shoulders makes the Unstoppable Fiend look more animal-like and dangerous.

2 The heavy-duty armor and mechanical claws and feet make this character appear threatening and inhuman. The wires and tubes add to the robotic appearance. Look at mechanical and technological devices around you for ideas.

3 As you color your image, keep in mind the textures you are re-creating. Metal will reflect light and appear, well, metallic. Notice how the circular highlights make the character appear shiny. Don't forget to add highlights and shadows to areas that are set into the figure.

Word Break

Oni (OH-nee)—mythical demons from Japanese folklore. They ravaged the land and could be stopped only by brave warriors and holy men. Oni were also guardians of treasures and passageways, obstacles that had to be overcome to win the rewards of the adventure. Oni always appeared fierce and seemed unstoppable, but were not very smart and could be tricked easily.

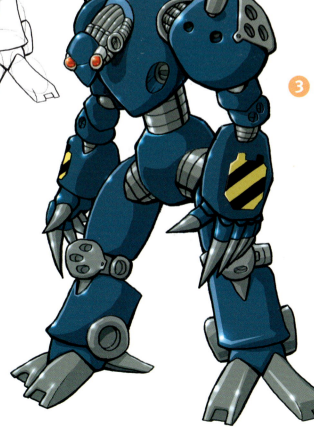

fantasy Warrior

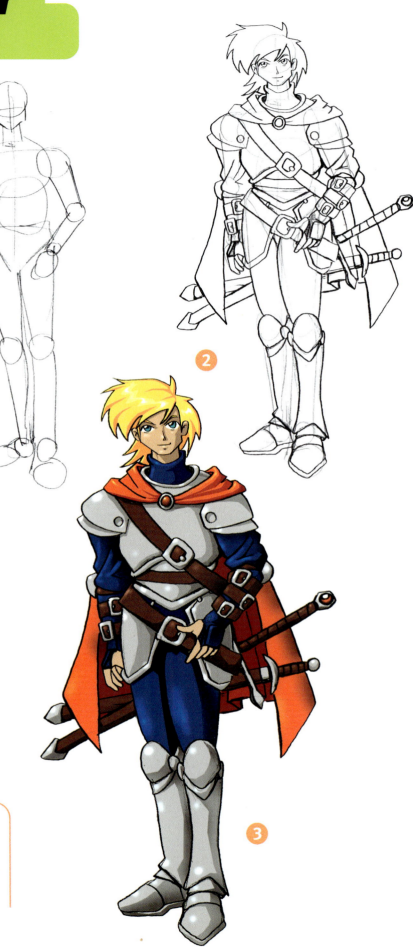

The Fantasy Warrior is the classic knight in shining armor. He is pure and just and always looks great, even when dragged through a wretched swamp by a fire-breathing beast. Some fantasy warriors are given oversized weapons and powerful magical abilities.

Pay close attention to the details of the weaponry and armor. Look to real armor for inspiration. Just understanding how armor fastens and attaches can make your drawing more realistic.

1 Make the Fantasy Warrior solid, but not overly muscular. Most of the bulk of the character should come from the armor and the cape.

2 Some of the details for this character were based on European arms and armor, but the warrior's weapons are based on the samurai tradition of wearing two swords, the *katana* and the *wakizashi*. His face is angular and a little battle weary, but his eyes and hair suggest the spark of youth.

3 Choose bright and noble colors that quickly identify the character as one of the good guys. Also keep the figure well rounded with light and dark shading. Pay attention to the shading of materials such as metal armor and folded cloth. Blond hair and blue eyes top off this classic warrior's look.

Dragon Slayer?

Slaying dragons is more common in European adventure-stories than in Asian ones. Instead of being evil monsters that spread devastation and terror, Asian dragons represent good luck and act as guardians, driving away evil spirits. In manga, dragons are more likely to be helpers than evil beasts.

elf princess
Warrior

Manga elves possess magical powers and control over the elements. They are closely linked to nature and able to communicate with elemental spirits of the trees, rivers and wind. Manga elves often provide an exotic love interest for the Fantasy Warrior.

1 Keep the figure long, lean and catlike. Make sure your lines are light and loose. Place her sword with a simple cross.

2 The armor should be light, allowing her to scramble through the forest, but still appear impressive and regal. The pointy shoulder armor echoes her long ears. Her skirt, gloves and boots have jagged edges, inspired by leafy foliage. A playful sneer hints at her personality.

3 Her red hair suggests boldness and a fighting spirit. Green was an obvious choice for a forest spirit, but any earth tone would be appropriate. The armor is some sort of strange iridescent elfin metal. The highlights on the hair and armor make her appear to shimmer. She is from a magical realm, after all.

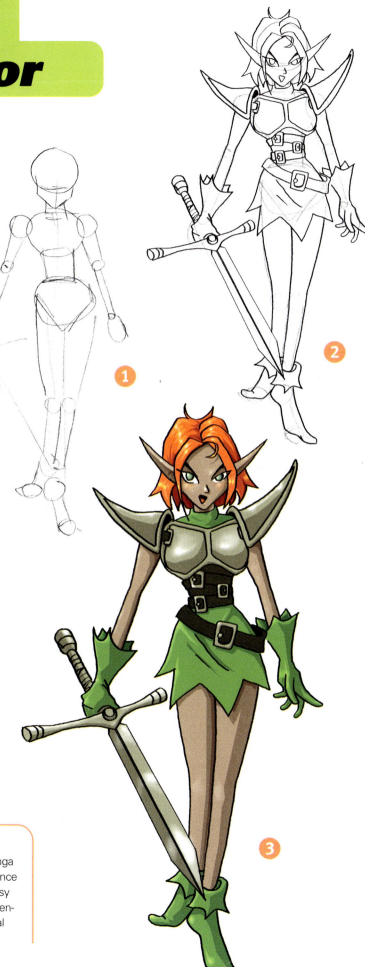

Fantasy Manga

Manga based on fantasy stories often employs elements of science fiction or technology in a unique way. Some manga uses medieval Japan as a design influence instead of the standard European fantasy stories. The combinations and experimentation create very distinctive and original stories.

| *martial* **Artists**

Some of the most popular shounen heroes are martial artists. Martial artists in shounen manga are not only masters of physical combat, but can turn their inner strength or *ki* into powerful energy blasts.

1 Start with sticks, ovals and circles to create a kicking base figure. Draw a line straight down from the head. This will show where the foot balancing the figure should be drawn.

2 Martial artists are strong, but not overly muscular. They use skill and spirit to perform impossible feats of acrobatics and combat. The limits of human anatomy should be challenged, but not ignored. To avoid drawing a flat figure, remember that a figure is built of spheres and cylinders. This will make adding clothing easier.

3 The clothing should twist, fold and contort in relation to the actions of the figures. I have drawn these characters in traditional-looking martial arts uniforms. You may notice that the female martial artist does not seem to have a mouth. This is a common tradition in manga and anime. It simplifies the face and focuses attention on the eyes.

4 Remember that the figures are 3-D, so light should wrap around their forms. Use as few lines as possible to suggest details like the heel of a foot, the knuckles and flexed neck muscles, but let shading define the rest. Notice that the female's jawline and ankle on her grounded foot are indicated only with shading. Good shading helps bring the characters to life.

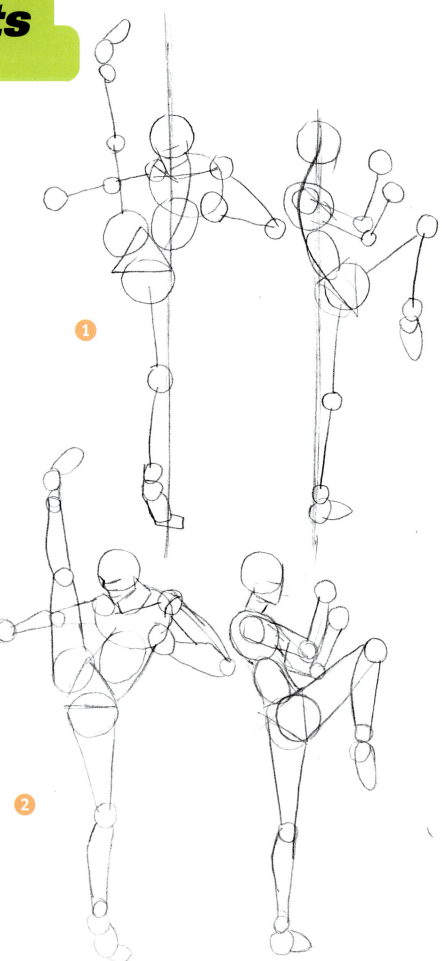

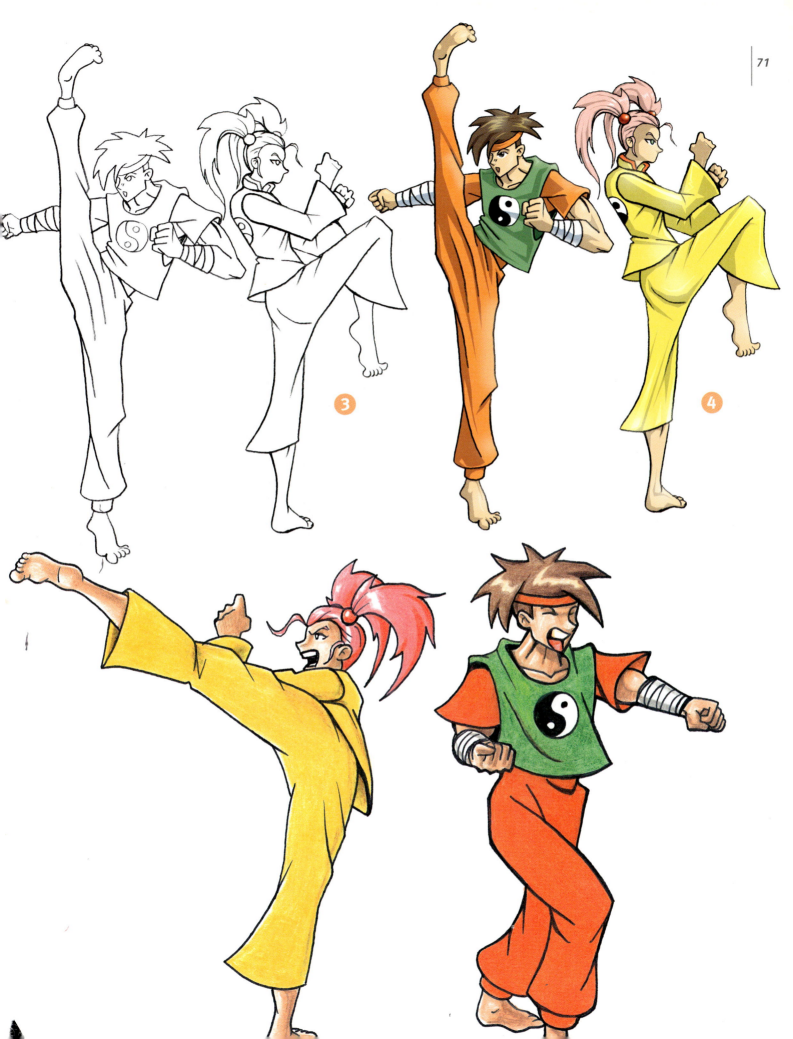

Cat Girl

Many, many manga have Cat Girl characters. Some stories just show characters dressed up in cat costumes. Sometimes the Cat Girl is an alien, other times she is a magical creature. Japanese folklore has a tradition of shape-shifting cats and foxes who can take human form and cause all kinds of mischief.

1 Keep your shapes bold for this pose. Review the proportions of the figure before you start, even if you are going to break the rules. Keep the shapes soft and rounded for a more feminine look. Some Cat Girls have big cat tails for balance.

2 What else would Cat Girl wear if not a cat suit? A few lines are enough to indicate her chest, torso and collarbone. Remember to make clothing details such as sleeves and belts wrap around the objects you draw. Think of each limb as a three-dimensional cylinder and wrap the clothing details around it. Her fur should move with her.

3 Keep the clothing colors bright and fun. Circular highlights make her cat suit look shiny. You may want to look at patterns that appear on real cats like housecats, leopards or tigers to get ideas on how to shade the fur.

Word Break

Neko (NEH-koh)—the Japanese word for cat, but also refers to half-human, half-cat characters found in manga and anime.

Android Boy

Like Pinocchio, the Android Boy likes to think of himself as a human, but he is so much more. He is a super-android created by a brilliant scientist. Using his robotic abilities as super powers, he is a help to police, the military and the scientific community.

Manga has dealt with robots and androids for decades. Many heroic androids have been young or inexperienced personalities such as children or teenagers. Manga writers and artists have dealt with the concept of artificial people in a very sensitive and creative manner. They aren't afraid to confront the issue of what being human is all about.

1 Since this character isn't human, don't be afraid to experiment with the anatomy. Feel free to add another eye or two or really exaggerate the "bunny ear" sensors. Use technological details to further express the character's emotions and tell his story.

2 The bunny ear sensors are a traditional reference to some androids and mecha in manga. They can be quite expressive and even cute. The shoulders have small bolts that can be structural or maybe canisters of coolant or hydraulic fluid. The tube or wire on the back could distribute the fluid to other systems. The fingers are some sort of weapons system. The large bubbles on the forearms and lower legs might be access hatches or even energy batteries.

3 Make Android Boy dynamic and colorful. He's one of the good guys and this will also distinguish him from the enemy robots. Use highlights and sharp contrasts to make his metallic "skin" appear glowing and reflective. A trail of smoke rising from one finger reinforces that his fingers are some form of weapon.

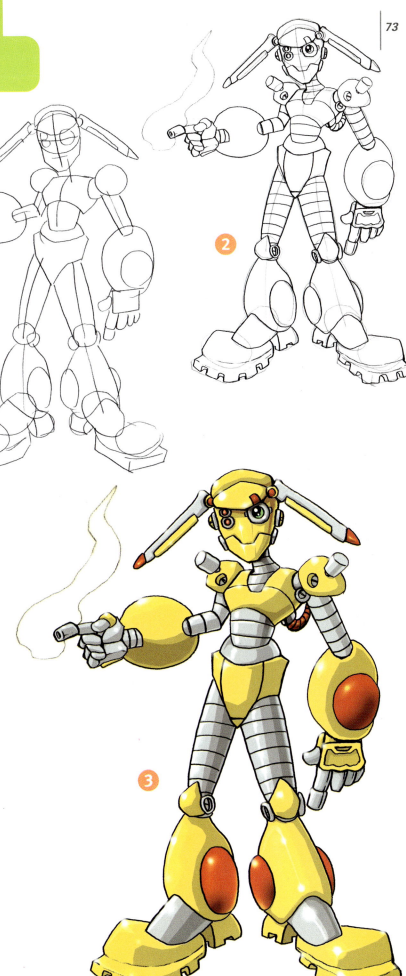

Victorian Rose
(bishoujo)

Bishoujo characters are often dressed in fancy gowns with big bows and puffed sleeves. They are often the object of affection for two rivals and must make a choice, often with dramatic consequences. Despite their fairytale-princess appearances, Bishoujo characters often can take care of themselves, and they wield plenty of their own power. They are usually more than just pretty faces.

1 Use the gesture study of the stick figure to develop a wistful, romantic pose. Even though her legs will be hidden by the dress, lightly draw the basic structure of the legs so that you get the proportions and the position of her upper body and feet correct.

2 Develop the costume details: puffed and ruffled sleeves, a frilly underskirt and bows on her neckline and lower back, topped with a delicate rose. Bishoujo characters should be gentle, rounded and have dreamy, graceful mannerisms. Tame hair and a mouthless face allow her innocent eyes to steal the show.

3 Shade and color the figure simply but don't forget to show the puffiness and folds of the cloth as you draw them. It's no wonder that cute little critters gather at the feet of this lovely lady!

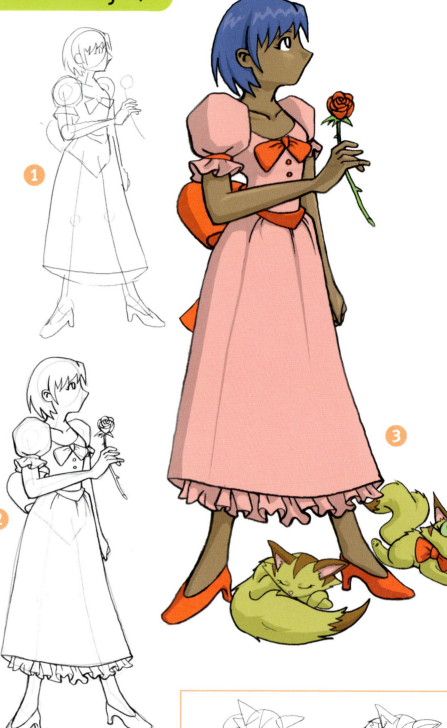

The Bishoujo Mascot

Don't get too complicated with the forms of Mascots. Stick to simple geometric shapes. Make the Mascots cute and cuddly. Mix and match details to create unique animals. In this case, the Mascots appear to be a combination of a cat, squirrel and fox. Details such as bows that match the bishoujo make a visual connection for the reader.

School Girl
(bishoujo)

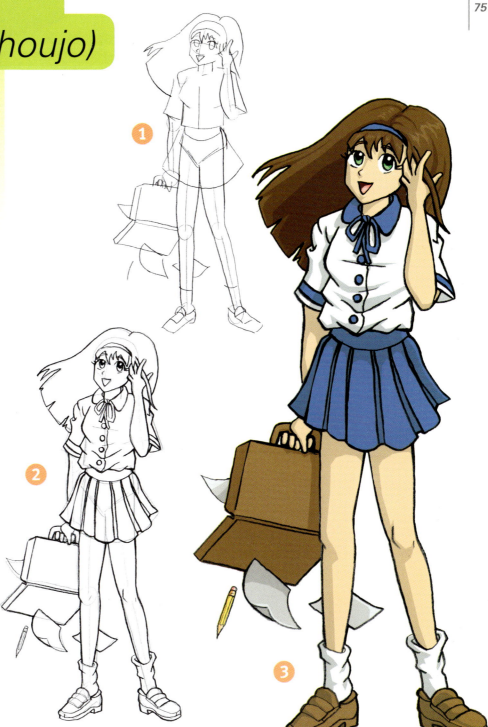

So many shoujo comics are about school life that it seems only natural to include the School Girl in this collection of manga character types. There is no standard school uniform for students in Japan, but the two basic styles are the sailor suit and the British school blazer.

1 Many manga stories about school life focus on the embarrassing crises of teenage years (like having your school briefcase burst open when you're talking to a cute boy). Pay attention to small gestures and body language clues. This girl is playing with her hair and looks fairly uncomfortable and awkward despite the smile on her face.

2 The folds in her loose, oversized socks really reinforce the cylinders that make up the legs. The fluttering papers are curved and drawn in three stages of falling to show the process of how a sheet drifts to the floor. Her moving hair suggests that she may have just turned around to greet her crush when her briefcase popped open.

3 Keep your color choices simple. Try to limit the colors you use in order to make the character appear consistent. Reinforce the forms of the wrinkles and folds with shading.

What's Your Blood Type?

You may notice that descriptions of manga characters from Japan often include the character's blood type. This information is included because of the Japanese superstition that a person's blood type can play a role in determining personality. So what's *your* blood type?

Type A people are said to be cool, collected, sensible, methodical and intelligent, but hide their true feelings.

Type B people are inquisitive about the world, but have the attention span of a ferret, often abandoning projects they were once excited about. They frequently appear cheery and eager, but really want to be left alone.

Type O people tend to get along with everyone. They seem competent and capable, but often make big mistakes.

Type AB people are believed to be very thoughtful and emotional, but are too critical of themselves and what they are capable of doing.

Victorian Gentleman
(bishounen)

Bishounen are often better classified as bad boys rather than tough guys. They are usually the mysterious helpers in shoujo comics, unattainable love interests who constantly distract and occupy the thoughts of the heroine. They often have a wild and dangerous nature that makes them even more mysterious and attractive.

Bishounen characters are usually long and lanky and have wild, uncontrollable hair. Dressing them up in tuxedos or formal wear reinforces the "beautiful boy" stereotype.

1 Much of what will be drawn in the end has been sketched out here. Try to break down every complicated object to its basic shapes and forms. The fact that his top hat is a cylinder is very obvious in this sketch. Notice that he is slightly off balance, leaning forward with almost all his weight on the leg on our right. Putting a character off balance creates tension and movement.

2 Use references to get the specifics of his tuxedo right. Leave white lines for the details on black (his coat buttons, lapel and arm lines and the highlights on his shiny shoes). Carefully observe folds and creases in the clothing to help show tension and 3-D form—for example, where his buttons tug at his vest.

3 His tuxedo is a conservative color, but his red eyes pierce out from behind his tangled mess of hair. Odd-colored eyes could reveal an alien or magical aspect of the character. He might be a vampire, a type of goblin, an alien or even a robot. Or, the eyes could mean nothing at all, but simply make the character appear more interesting or whimsical.

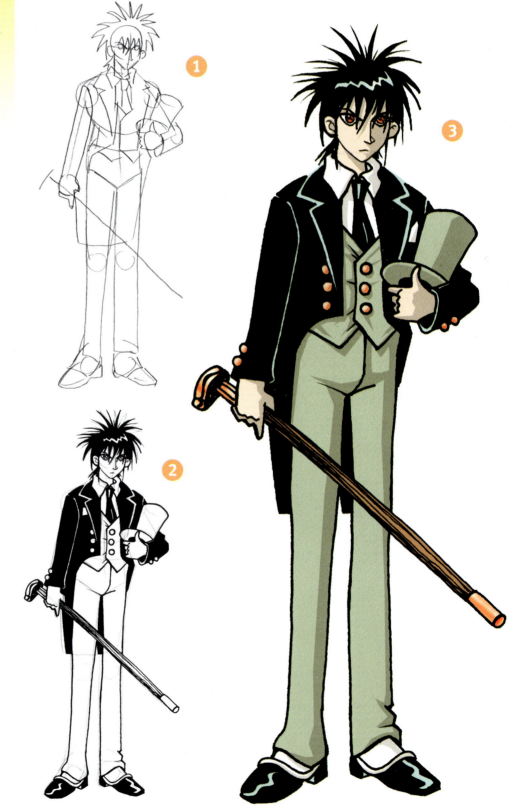

Hipster Student

*T*he details of this school uniform are not accurate for modern Japan, but it would work in a story of another place and another time. Bishounen characters like this one are often filled with angst and brood over even the smallest decision.

1 Observe costume details such as the cut of the jacket, the curves of the pant legs and the jacket sleeves. Wrap the clothes around the basic body structure.

2 The clothing folds and creases on his lower legs, elbows and waist give the figure a strong sense of 3-D form. Use your references to draw details like the jacket lapels and the briefcase. He's turned slightly to the side, so the shoulder and lapel farthest from us will look narrower, and we'll see only a hint of the buttons on that side.

3 Keep the color choices simple. Too many colors can make a drawing difficult to follow. The most striking thing about this character is his blue hair, which symbolizes his exotic nature.

Male or Female?

In manga you'll find characters that appear somewhat androgynous—having male and female characteristics. This might be a nod to the historical tradition of Takarazuka theater, where female actors played male roles. This tradition lived on in the comics originally based on Takarazuka stories.

Skate Girl
(shounen youth)

Youth and popular culture are very influential in Japanese media. Shounen manga does not always focus on young male heroes. There are many strong female characters in shounen manga who are quite capable, like the spunky Skate Girl.

1 Block out the forms as usual. Review the proportions for teenage characters. Remember to avoid cutting off the back of the skull when you draw the head from a three-quarters view.

2 Her inline skates give her movement and agility and may explain the tear on her sleeve (perhaps an unexpected spill?). Her pouty, realistically drawn lips emphasize her attitude. Her buckles and multiple belts add a fun sense of style. On her shirt are the Japanese Kanji characters for *mirai*, meaning "the future."

3 Try very hard to keep the light source consistent. Again, use the eye highlights to keep track of the light direction. Use light and dark to make the figure appear three-dimensional. Use gray to shade areas of white. Shading the legs gives them form. Round highlights on her cheekbones, nose, chin and eyebrow brings form to her face.

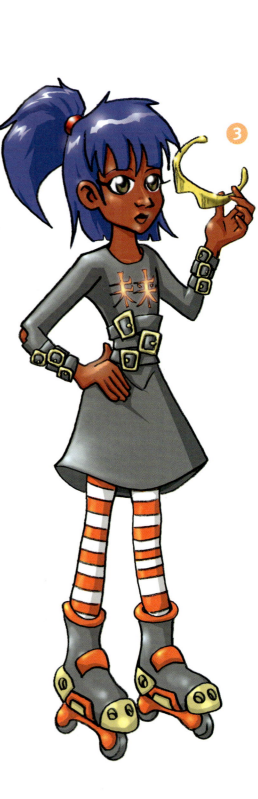

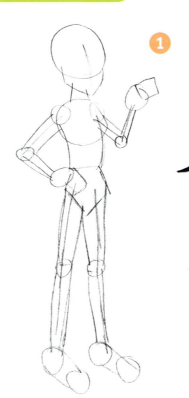

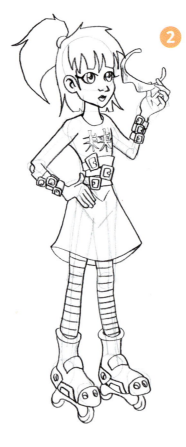

Cyberpunk Kid
(shounen youth)

Cyberpunk heroes often use lots of advanced technology or are partially or fully mechanical. Countless manga are about technology and how humans relate to it: what it means to be human in an age of rapid technological change. No matter how pretty the technology, don't forget the humanity behind it all. Try to make the cool robots and gadgets secondary to the people who populate the world of your story.

1 Block in the anatomy and stance. I wanted this character to have a strong, open stance, as though he is summoning great power and getting ready to use it. Make sure you give his head enough room for the back of the skull.

2 His gloves and headphones are attached to his backpack, which may hold a power source or even a portable computer. The gloves may increase his strength or possibly allow him to fire blasts of energy. Flame-edged jeans, a pair of sneakers and spiky hair are perfect for this wild child.

3 After adding color, use shading to show the wear and tear on his jeans, the creases of his white shirt and the highlights on the metal glove and his hair.

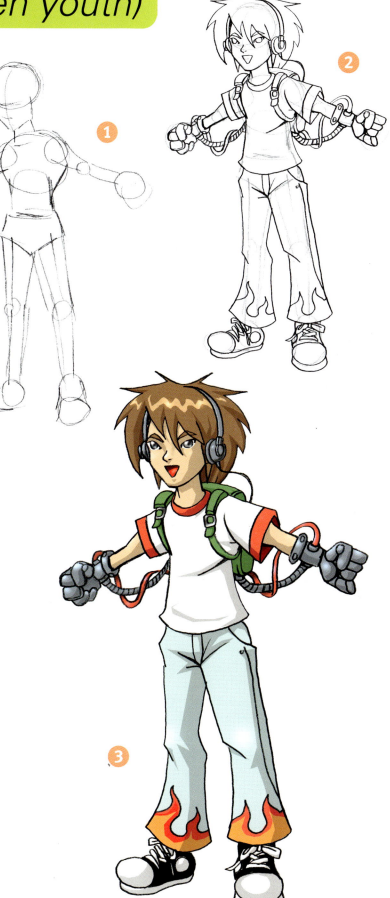

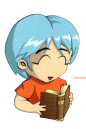

Shounen Adventure

Shounen manga are usually about some form of conflict. They are filled with thrilling chases and cool technology. Keep this in mind when you are designing characters. Planning ahead can help the stories write themselves.

Space Hero

Countless shounen manga stories are set in the future, with fantastic spaceships and giant robots. There is usually an aging captain or commander of the heroic forces who sends his team, his "children," off to battle a threat from space. The Space Hero is usually young and optimistic, and is often too reckless for his own good. His Mascot is usually a robot or furry alien, but can even be the spaceship the heroes travel on.

The sides of good and evil are not always clearly defined. The "villains" usually have a reasonable motive, but they are too aggressive or deceptive in their actions. There is often an honorable duel or showdown between the hero and the enemy, where a mutual respect reveals that in other circumstances the opponents could have been the best of friends.

1 Make sure your drawing has consistent proportions and indicates the action or movement of the hero. Think interlocking 3-D shapes when drawing the figure; this will make it easier when you add details like clothing or equipment.

2 Make the specifics of your hero's costume fit in with the other characters' outfits. Starting with one basic space suit and adjusting the details depending on the character is easier than coming up with a completely unique design for each individual. Let some of the costume details have a purpose. The thrusters on this hero's backpack may allow him to jet from place to place.

3 Flip to pages 110–113. This hero's color scheme is similar to what is used for the spaceships that battle the pirates. Again, try to keep the look of the story integrated with everything else.

Space Pirate

*O*ne thing that manga does very well is mix time periods and categories. Combining pirates with spaceships blends the swashbuckling thrills of a pirate story with the adventure and technology of science fiction. Giant robots often wield large energy swords like giant knights or samurai.

1 There is more information in this drawing than most of the first steps in this book, but at this stage you should have more confidence in your basic figure drawing. The collar, cuffs, hat, puffy pant legs and props such as the pistols are all blocked in at this stage.

2 The skull and crossbones identifies her "side" quickly. You may want to add other pirate trappings such as the sleeve cuffs. Details such as the glasses give us more information about this character and may set her apart from other characters in the story.

3 The costume is colored to make it appear loose and comfortable while maintaining a militaristic appearance. Her blue hair reveals her wild nature. This character seems ready for pirate adventure.

Futuristic Manga

Though some of the galaxy-spanning sagas that appear in manga are far-fetched, many manga stories have been on the cutting edge of the science fiction and scientific movements. Manga is respected by fans for dealing with hard sci-fi issues such as robotics, semi-realistic space travel and the social impact of new technologies.

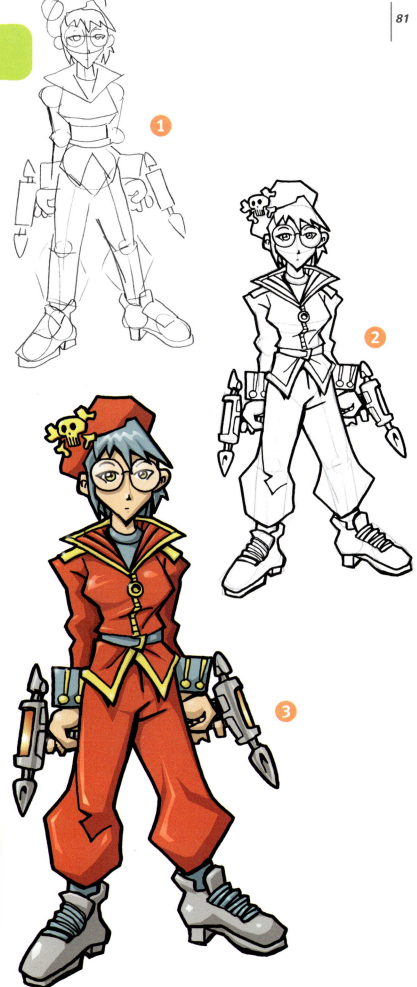

Mecha

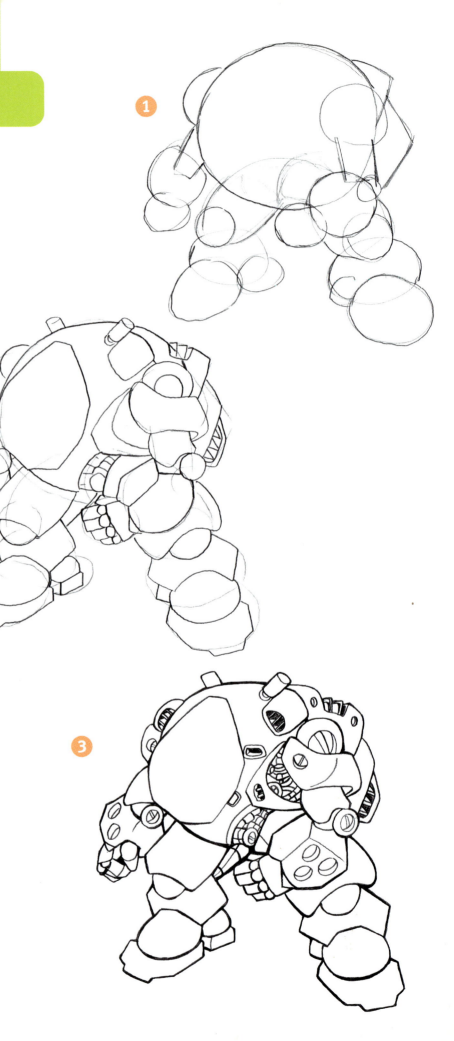

Giant robots are usually referred to as *mecha* or *mechs*, short for "mechanical." The term can refer to vehicles like super jets and cars as well as giant robots. Mecha are a staple in manga and anime. Japan's appreciation of the robot may be due in part to the use of robotics and technology in building that country's national economy, where robots and electronics do everything from building cars to milking cows.

1 Block in your basic shapes loosely. Try to capture the look of the mecha in a few simple forms. This mecha is squat and powerful. Keep it simple. The details you add next will suggest themselves as the robot appears on your paper.

2 This mecha has a large hatch in the front where the pilot climbs in and out of the cockpit. It is probably around fifteen to twenty feet tall. Mechanical details such as wires are exposed where the leg connects to the torso. The tubes on the top could be power cylinders or sensors. The pack on its back is the engine and fuel area.

3 Vents and cooling fins add a sense of logic that helps convince us that the robot is real. Add more wires and other mechanical details to make the mecha more believable. Bolts hold its individual pieces together.

4 This mecha appears designed to muck around in a swamp. It is splattered with mud and looking a little grungy. Try to make the metal parts really shine using highlights, shadows and reflections.

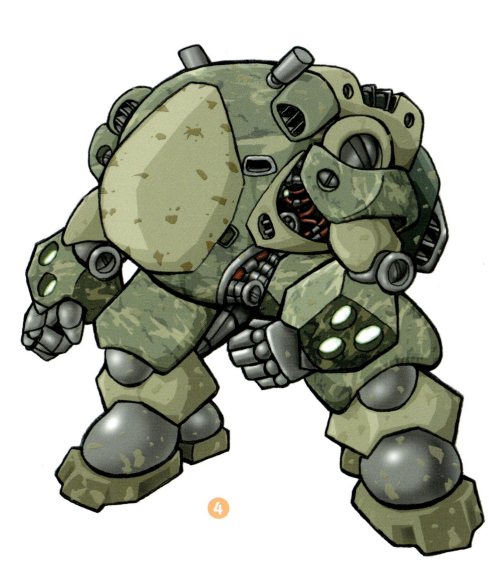

④

What's Underneath?

A closer inspection of the mecha will reveal possible technology under all that armor. It can be very rewarding (and fun!) trying to understand what makes your mecha tick. Take it apart and try to account for each part. Where does it get its power? Where does the pilot sit? Don't be intimidated by drawing all that technology. Have fun with it.

Pilot or Remote Control?

Mecha may be either piloted or run by remote control. Either way, the shape and form of a mecha may be more or less humanoid as the artist sees fit. A mecha without a head, for example, would not seem too bizarre if there was some indication of where the operator sat or received information.

When designing the look of the mecha, try to avoid the "tanks with feet" effect. You don't want it to look too clunky and vehicle like. Mecha may have practical technical considerations, but they should also have some life or character. Readers should worry about the mecha as well as the characters. Manga mecha are sometimes even more popular than the characters who pilot them.

Humanoid robot

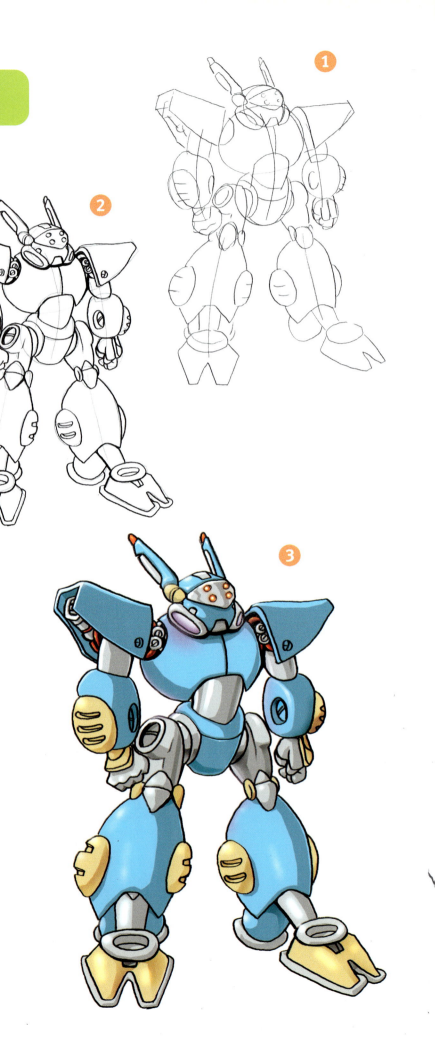

If you are going to draw lots of different kinds of robots, you need to have a clear idea of how they work. Some giant robots are powered by crystals and magic energy. Most are powered armor suits that are operated by a pilot seated in the head or the torso. Some mecha are hundreds of feet tall, while others are designed to be outfits that protect the wearer and increase his or her strength and abilities. Your design options are limitless.

1 Block out the shapes and think about the details that you want to add. What head shape will the robot have? What kind of sensors? Shoulder pads? Move from body part to body part and make decisions. Try to keep the design unified with similar arm and leg treatments. Repeat shapes and details for even more unity.

2 Try to give thickness and form to the details you've sketched. Make sure that all the parts look like they belong to the same robot. Your giant robot isn't human, so you can have fun modifying proportions and changing anatomy. Expose some mechanical details such as hydraulic pistons and wires. You may not know much about engineering or robotics, but that shouldn't stop you from drawing high-tech equipment.

3 Keep track of details you like about this mecha and reuse them for other drawings. After a while you will be able to mix and match elements to create an infinite variety of mecha.

Crab Bot

Mecha come in all shapes and sizes. They can be inspired by a human or animal, or resemble nothing natural at all. Since mecha are built and not born, their proportions and anatomy do not need to accurately correspond to their real-life counterparts. Try basing a robot on a human or animal, then exaggerating one or more of its features for the mecha form.

1 Crabs and spiders are traditional inspirations for mecha in manga. Keep your shapes simple at this stage. High-tech doesn't mean hard to draw.

2 Carefully add details and clean up the lines. The bunny ears are sensors. There is one main optical sensor along with several smaller sensors.

3 Dents in the surface of the mecha mean it has seen some damage. This robot might be used to move through difficult terrain or act as a search and rescue mecha. A spy bot might have a camouflage feature that changes the color of its armor to match its surroundings, or a cloaking device that renders it virtually invisible. This mecha might be the size of a minivan or fit into the palm of your hand.

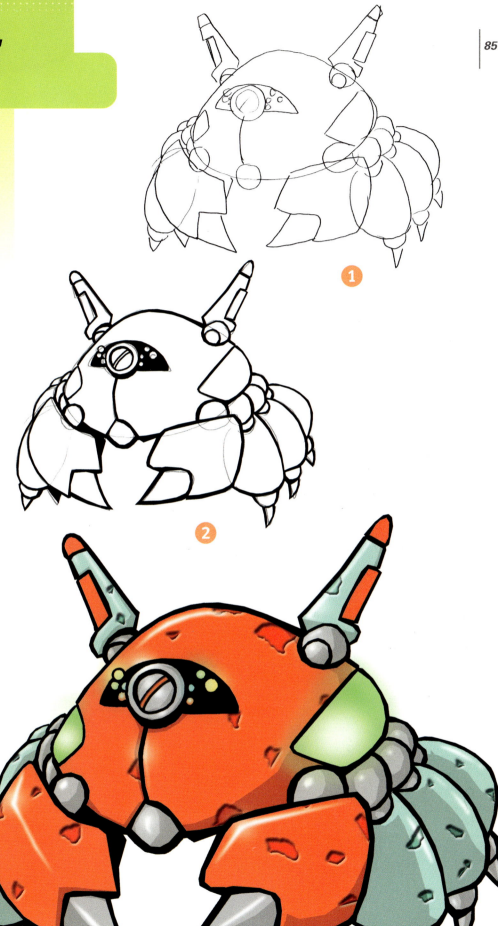

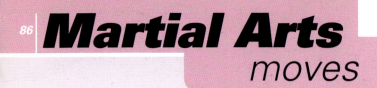

Martial Arts
moves

Elaborate martial arts battles are exciting and typical in manga, but they sure can take up a lot of space. Climactic hand-to-hand combat has been known to take up fifteen pages or more of a storyline! Unless you repeat the same actions over and over, that's a lot of moves you're going to have to draw.

Don't draw *every* move and detail of a martial arts contest. Take shortcuts. For example, you can show a punch being thrown by the hero in one panel, and then the villain crashing into a wall in the next panel. The reader will fill in the blanks.

Each martial art has a unique fighting style. Some styles like *wu xia* (wu shu) combine acrobatics, empty-hand techniques and weapons for a very flashy show. Keep a sketchbook filled with action poses like the ones you see on this page, which are karate and kung fu moves. Rent a few martial-arts movies and pause the film to sketch the fancy moves. Try sketching a combat sequence from start to finish. Show the balance in the stances and the power in the attacks.

Clash Course ◗

When showing combat in manga, make sure to spend time building up to the actual fight. A fight scene usually begins when words are exchanged in a standoff. Then some sort of display of power or skill is performed by one of the characters. When the combatants finally begin to fight, it is often depicted as a moment frozen in time. After this first clash, the characters usually fall back to lick their wounds and trade insults again before another power-up and assault. Cause and reaction is just as important as the action.

Swords
and weapons

If your characters are going to wield weapons, consider the weight of the weapons they are holding. Try to show the work and effort required to lift the sword. Fantasy swords are heavy; they are basically just sharp clubs. There should be strain on the arms, and the shoulders should droop. Pool noodles are light in comparison and they take little effort to carry and swing. Show the difference.

Do some research when you are planning your manga action. Try swinging a broom stick around in front of a mirror (carefully, of course) and pay attention to the angle of your wrists and arms as you swing the weapon. Try to show what feels natural.

Characters can express their personality in their fighting style. Some characters are flashy and extroverted, while others are careful and precise. Know your characters so that the actions you create for them make sense.

Even a loose drawing should show the weight, flow and force of the character as the action is performed. This sequence begins with a defensive posture, continues with a wide, sweeping strike, and ends with the character gearing up for another strike. Draw swords and other weapons as an extension of the character wielding them.

running and the Chase

Be prepared to draw running action from every angle. Pay attention to the spine or central line of action as you draw running characters. Putting the central balance of the character off-kilter adds to the sense of desperation and energy in the drawing. Try to show the character's hair and clothing as it is swept back in the wind.

Give your characters something to run about!

Running Man

Look out! This guy is running toward us with a great amount of energy and power. To draw him yourself, start by having him push off from the ground, putting all of his weight on one leg or both. He should look tense, like a coiled spring. As he is leaping, show that he's ready to land with the next leg and loosen the body language so that he appears to be flying through space.

jumping and Acrobatics

The key to showing realistic jumping and acrobatics is to know the difference between jumping and falling. Jumping is all about confidence and focus. The character should appear ready to strike or land. Characters who are falling appear out of control. When you draw a figure jumping or performing any sort of athletic or acrobatic skill, keep a close eye on balance and weight distribution.

Even if you are working from a reference like a photo or another drawing, it is important to know exactly where each part of the body is and what it is doing. Once you know the anatomy well enough, it is fairly easy to draw the figure doing almost anything. Playing around with an action figure or doll can help you with more difficult poses.

Understand what the parts of the figure are doing as they fly through space. This ninja's arms are wild and open. His legs appear springy and powerful. One leg is slightly lowered, getting ready to land.

Making the Leap
The arm supporting the weight of the figure should appear locked and powerful as the legs swing over the object that is being leapt over. Exaggerating the figure's forward movement and keeping the arms and legs expressive and active gives the middle drawing a sense of energy. As the character leaps into the air, the arms are used for balance and the legs tuck up to the torso.

As the ninja hits the ground, see how he absorbs the shock of the landing by crouching into a ball. His turned head lets you know that he is in control of the landing, and alert.

other kinds of Action

Manga is not all about jumping and fighting. The range of stories from humorous, slice-of-life drama to alien-stomping schoolgirls is part of the attraction. You are going to have to draw your characters doing a variety of activities.

Remember that in any story, the main goal of the storyteller is to develop a character. A character-driven plot is much more interesting than an event-driven plot. Make the development and interaction of characters the focus of the story. Make your characters act, not just react to what is happening around them.

Manga doesn't move like animation. It is up to you to show the most infor-mation about a movement as you can, and let the reader's imagination fill in the rest. Work out the expression and the gesture of the action in a loose drawing before you start adding too much detail.

You can tell a lot about people by the way they move. The obvious air of superiority this girl pos-sesses is expressed by a purposeful stride, swinging elbows and a turned-up nose. However, the boy behind her seems to be mocking her while looking at the viewer as if to include us in his little joke at her expense.

Manga allows for a wide range of exaggera-tion and expression. Even the most tragic act of crying can be played for laughs. It is even funnier if the other characters stand on either side of the weeper and catch the fountains of tears in buckets.

The fun shouldn't end there. Let the helper slip and fall. It's much more interesting to show the character in mid-fall than it is to show him already fallen. Try to depict the moment that would be the most intense for the reader and the character.

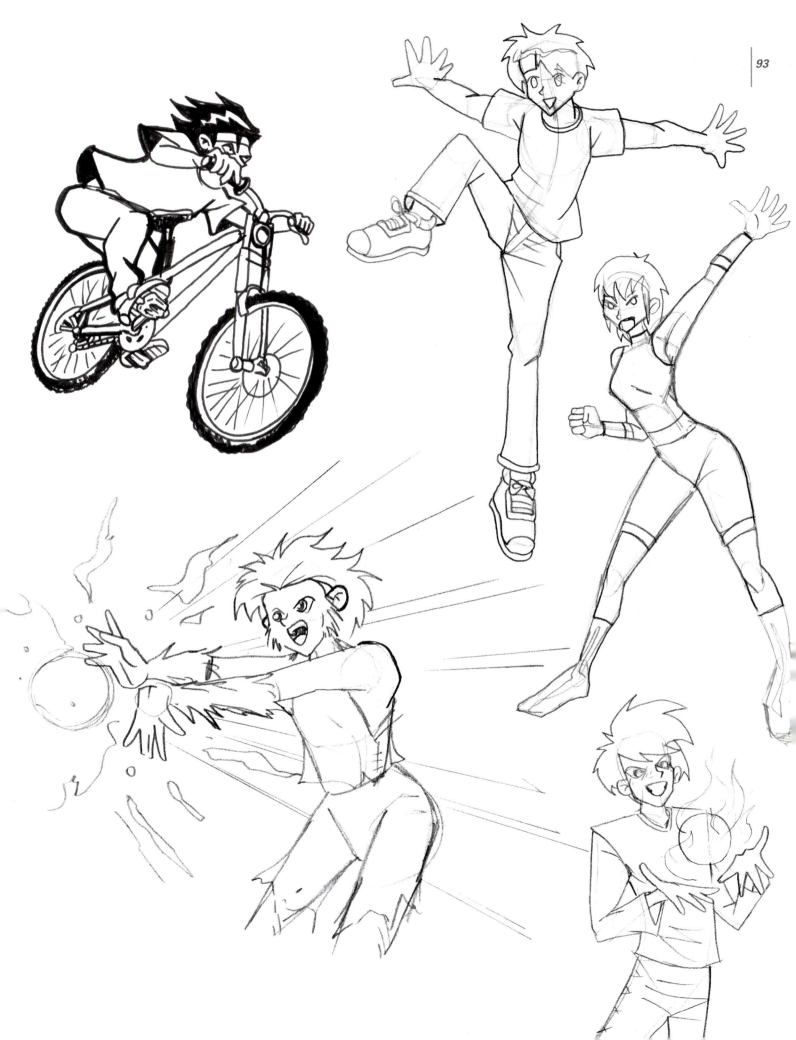

the basics of Linear Perspective

Linear perspective is a technique that allows you to make the flat surface of your paper appear to have depth. Manga artists use it to help draw the complex backgrounds that help establish the setting of the story and place characters in that setting. Here are the three types of perspective you need to know to create convincing three-dimensional settings.

One-Point

In one-point perspective, all the parallel lines in your drawing appear to meet at one point on the horizon, or eye-level line. All of the parallel lines that recede or go back in space must converge at this one vanishing point. The rest of the lines are parallel to the edges of the panel or paper. Imagine you were walking down a street lined with buildings. The lines of the road and the horizontal lines of the windows, doors and building bricks would all appear to point toward a single spot on the horizon.

In a one-point perspective drawing, the vanishing point acts as a natural focal point because all the lines seem to point toward that single spot.

Two-Point

This perspective allows for greater realism in a drawing. In two-point perspective, there are two vanishing points on the horizon where lines converge. Now imagine you're standing on a street corner, facing the corner of a building. The horizontal parallel

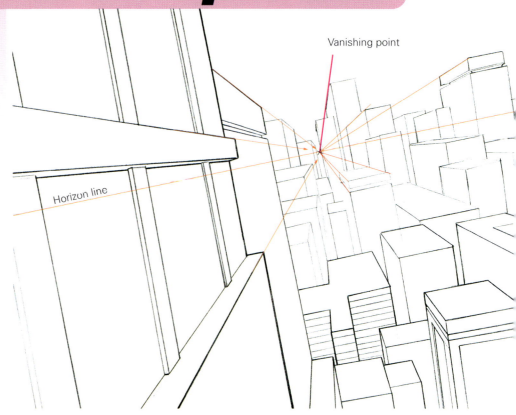

Vanishing point

Horizon line

One-Point Perspective

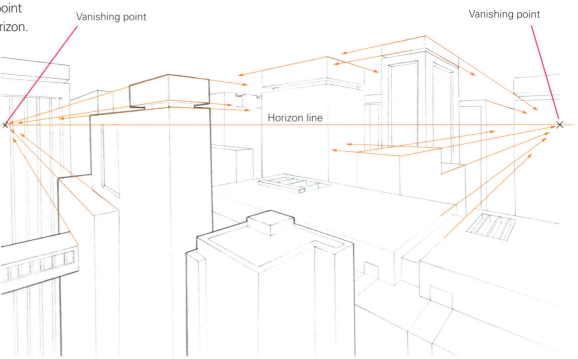

Vanishing point

Vanishing point

Horizon line

Two-Point Perspective

Vanishing point

lines on your right will appear to meet at one spot to your right on the horizon, and the lines on your left will seem to meet at another spot to your left on the horizon.

The only true horizontal line should be the horizon. The rest of the lines converge at their respective vanishing points on the appropriate angles. In two-point perspective, vertical lines should line up parallel to the edge of the panel.

Sometimes the vanishing points might be located outside of the boundaries of your picture. Drawing shapes too close to the vanishing points could cause unwanted distortion. Consider taping an extra piece of paper containing the vanishing point to the page so that you can actually see it as you draw, until you are more comfortable drawing in perspective.

Three-Point

Three-point perspective is a more expressive form of perspective drawing, which can produce some very dramatic results. Three vanishing points are chosen. The first two points are

selected just as in two-point perspective, but the location of the third point depends on whether you are looking up at your subject or down on it.

Place the third vanishing point at the top of the page if you are looking up. For example, if you are looking up at an office building, the floors above your eye level will appear to get smaller and smaller and the shape of the building will appear as if it is being drawn up toward the third vanishing point. If you are looking down at the building, then the third vanishing point will appear to drop off the bottom of the page. In this case, the floors below you will appear gradually smaller.

Vanishing point Horizon line Vanishing point

Three-Point Perspective

drawing figures in *Perspective*

Considering the relationship of the figure to the space around it is an important perspective trick to make the drawing more convincing. Characters should be in proportion with their surroundings. Doors in the background should never appear too small for the character to enter, or too large. Everything must relate proportionally with everything else as it recedes into the perceived space. It's all about relative heights and how objects that are farther away appear smaller.

Always keep in mind the viewer's point of view when you are drawing your characters. The horizon line is the eye-level line. Any character above or below this line will appear above or below the viewer's point of view.

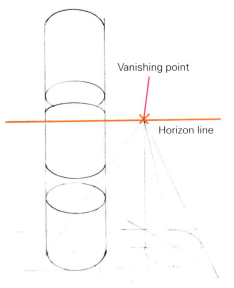

Draw Cylinders as You See Them

One very common drawing mistake most beginners make is drawing the bottom of a cylinder, such as a can of soda, flat. We know that the bottom of the soda can is flat, but when we look at a cylinder in space, we can clearly see that the bottom of the object appears to be more of an ellipse or oval shape. The same is true for the top. The oval gets narrower as it approaches the horizon line and disappears when it rises above the horizon line, or our eye line. We then see the bottom of the cylinder as it rises above our eye line.

To correctly draw an ellipse, draw a square in perspective first, then draw diagonal lines from corner to corner to locate the center of the square at the intersection. The ellipse can then be drawn as four careful curves that touch the sides of the square at four points.

Vanishing point

Horizon line

Vanishing point

Horizon line

Vanishing point

Don't Draw Flat Feet

The same perspective rules that apply to objects apply to figures. Many beginning artists draw feet flat across the bottom and place them at the same level. It is a logical error: we know the bottom of our feet must be flat on the ground or else we would fall over. However, as the feet are well below the horizon line, you will see their tops and they will appear to be at different levels from each other depending on how they are pointed. The heels should appear to be the same level below the horizon line.

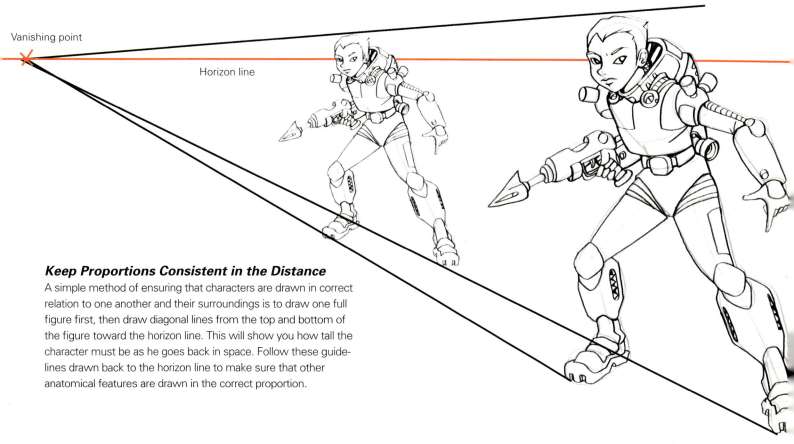

Vanishing point

Horizon line

Keep Proportions Consistent in the Distance

A simple method of ensuring that characters are drawn in correct relation to one another and their surroundings is to draw one full figure first, then draw diagonal lines from the top and bottom of the figure toward the horizon line. This will show you how tall the character must be as he goes back in space. Follow these guidelines drawn back to the horizon line to make sure that other anatomical features are drawn in the correct proportion.

Eye Contact

Characters whose eyes are located at the horizon line are the same height as the viewer and will become the focal point of that drawing because they directly engage the viewer.

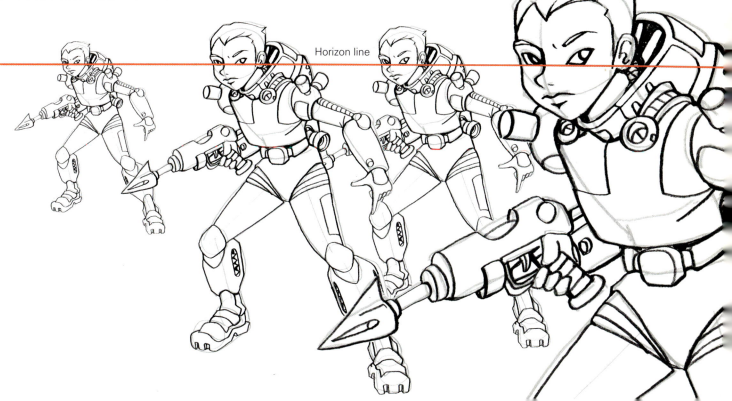

Horizon line

city **Buildings**

The background or setting in your manga is important because it often provides visual clues to what is happening in the story. Many manga stories take place in an urban setting. Collect photographs and drawings of cityscapes so you can refer to them for ideas as you draw. Common objects such as phone booths and fire hydrants are nice touches that can really bring a scene to life.

Let's try drawing some city buildings in two-point perspective.

1 The first thing you need to do in any perspective drawing is establish the horizon line and the vanishing points. Draw a few vertical lines that will become the corners of buildings.

2 Take things one step at a time. Use a ruler and draw lines back in space, leading to the two vanishing points, to create a collection of boxes. Use your photo references and other resources to begin adding details in an effort to make the structures look less like boxes and more like real buildings.

3 Once you finish developing the boxes into buildings, create some buildings in the background. Objects that are farther away will appear smaller, be overlapped by closer objects and have less detail.

4 The colors on distant buildings should be less intense, or duller, than the buildings closest to us. Light and shadow add realism, so don't forget the shadows cast on the buildings and the ground. You will probably want only a small section of your drawing to act as the establishing shot or a background for the scene. Feel free to zoom in and show only what you need as your final product.

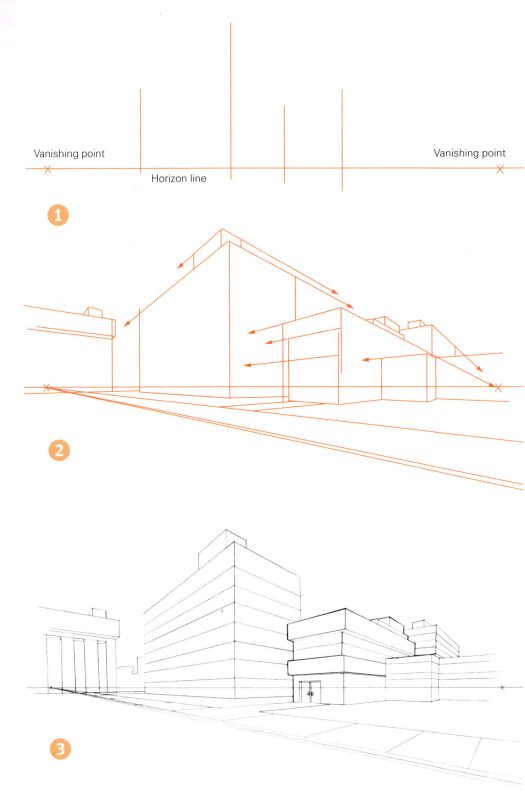

Vanishing point

Vanishing point

Horizon line

1

2

3

4

fantasy Castle

Western fantasy has been a relatively recent addition to manga. With the rise of role-playing video games using fantasy settings, more manga and anime have been produced in this style. Use photo references or other illustrations to help you fully realize the details of your setting.

Try this one-point perspective drawing of a room leading out to a balcony in a medieval castle.

1 Establish the horizon line and single vanishing point first. Using a ruler, block in the lines of the floor, doorway and balcony railing. Draw the archway as a rectangular door for this first step.

2 To draw the arch, first find the center of the rectangle that forms the doorway. Do this by drawing diagonal lines from the top corners to the bottom corners. The spot where the two lines intersect is the center. Draw a vertical line that crosses over the center of the door. Now draw the archway, placing the highest point of the arch at the top of the vertical line. Because the viewer is looking up at the archway from the left, draw the underside of the arch showing more of the right side than the left.

3 Now add some details to make the scene come alive. Getting the floor stonework right is key to creating depth in this scene. Generally, the stones closest to the viewer should be biggest, and gradually become smaller leading out to the balcony. The mace and chain are simply a sphere and cylinder drawn to a separate vanishing point along the horizon line. Even though this is a one-point perspective drawing, adding another point where an object that is out of alignment can be drawn in perspective is still accurate. The background mountains are more distant than the castle tower, so keep their lines lighter.

Horizon line

Vanishing point

1

2

3

4 When shading, remember that this drawing has two light sources: the outdoor light and the lit torch. A golden glow from the torch sets the mood. Make the stonework look real by roughing up the stones with some texture. Use less intense color for the distant mountains. Notice how the blue sky fades as we move from the top of the arch to the mountaintops.

space Station

Much of what was once science fiction has become reality. A space station may be a perfect location for some manga, but if it is not appropriate for your story, you could easily convert this scene into a classroom, shopping mall or restaurant.

Let's create a space station in two-point perspective.

1 Start by placing your horizon line and vanishing points, then draw your first structural lines. This will eventually become a room on the inside corner of an L-shaped hallway. The vertical lines of the column in the center show where the room ends.

2 Add more lines, considering the details you will place later. The rectangle in the hallway will become a huge window through which we can see the galaxy, and the rectangle within the room could become a computer or radar screen. I've added a lot of lines to the ceiling to indicate where lighting and exposed wiring and space station hardware will go. Remember to make each of your lines go back to a vanishing point. Draw lightly so that if you make a mistake you can easily fix it later.

3 Now it's time to make this look like a space station. Let your details provide plenty of visual clues about the setting for your story. The wall to the left of the radar screen looks like it may hold a massive sliding door leading to another section of the station. If you want, look at pictures of high technology for ideas.

4 The last drawing includes some complex shading because of the multiple light sources and the textured metal floor. Notice how the floor pattern and the yellow and black stripes closest to us appear the largest. Adding a view of the galaxy outside the window creates a greater illusion of depth and location.

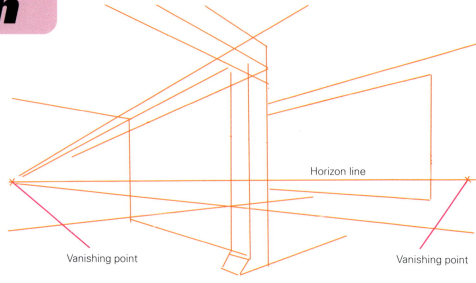

Horizon line

Vanishing point

Vanishing point

1

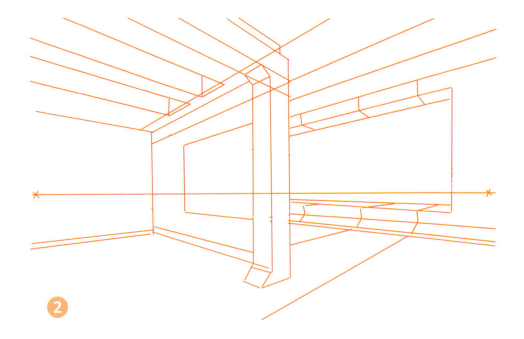

2

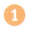

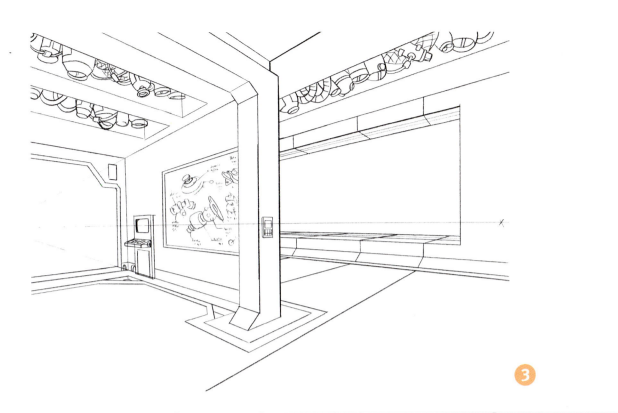

3

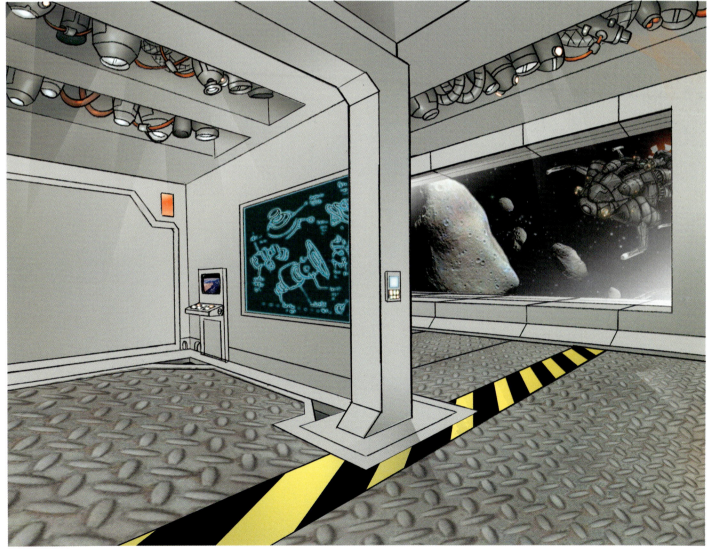

4

traditional Japanese home

Traditional Japanese homes are simple and tidy with wooden floors, sliding paper interior walls and relatively little furniture. Guests remove their shoes before entering out of respect, but also to save wear and tear on the straw mats and wood floors. Guests sleep on mats or futons that are rolled up when not in use. The home's beauty lies in its simplicity and the peacefulness of the garden that surrounds it.

Not everyone in Japan lives in a traditional home, as they are considered to be old-fashioned, quaint, and somewhat impractical today. A home such as this one would be appropriate for a story set in old-time Japan, or one that stresses the ritual and tradition of Japanese culture.

1 Draw your horizon line and vanishing point for this one-perspective drawing. Keep things relatively simple. You can see another room through a door made in the wall by pushing together sections of wall and sliding them aside. This creates an even larger room.

The trickiest part of this drawing is the ceiling. The beams that are visible are on a fixed angle. This represents the sloped roof of the traditional Japanese home. Keep these lines parallel, remembering that they should get closer together as they recede in space.

2 Draw the wooden floorboards and ceiling planks by carefully measuring the spaces along the bottom of the back wall and bringing the lines forward from the vanishing point.

3 Clean up the lines and erase any extra lines that might make the drawing difficult to understand. Block in other setting details, including the windows and the garden outside. The lines of the roof overhang outside should be closer together as the overhang moves back in space. The house

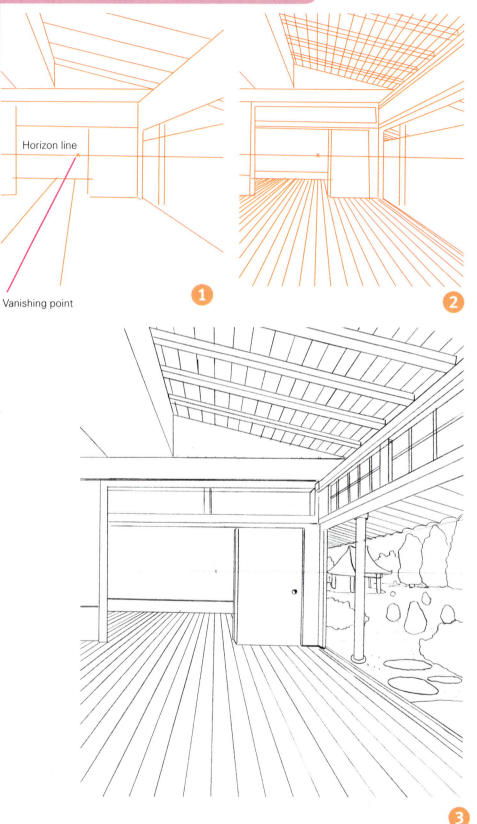

Horizon line

Vanishing point

1

2

3

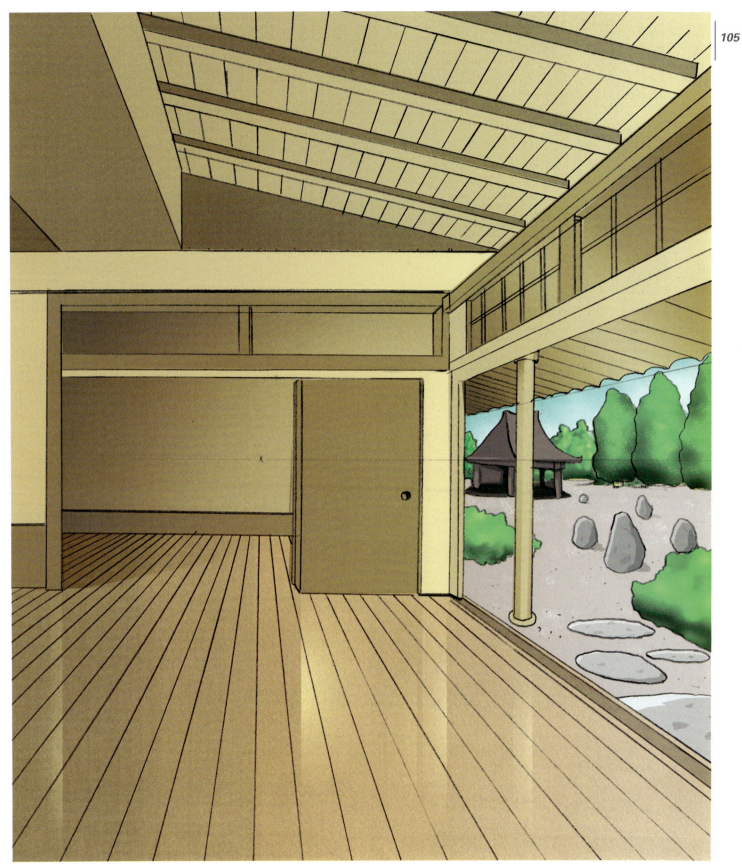

opens up to the garden, successfully integrating the man-made environment with nature. This creates a sense of balance and harmony in the architecture. Wood and paper doors slide closed, allowing this area to be closed off.

4 The reflection on the floor gives the viewer the impression that the wood has been freshly buffed. Notice how the rocks in the garden get progressively smaller in the distance, and how small the building in the background looks compared to the house. Details like this help create depth.

4

Vehicles

Just like drawing characters, drawing vehicles is a matter of breaking down complex objects into basic geometric shapes. Cars, jets and spaceships are built out of the same types of shapes and forms as figures.

Spend a large amount of your drawing and doodling time figuring out how things are put together. When you get comfortable drawing this way, you should be able to take the image of an object in your imagination and rotate it, checking out every side. If you don't have an easy time visualizing, take a look at a toy and draw from that. It's easier to turn a toy car around in your hands than a real one, that's for sure!

The details of the vehicles you draw may be cool, accidental or whimsical, but they should always add to the story and be somehow functional. If you think things through early on, it is easier to explain what "that button" does later.

A jumbo jet doesn't look too complicated to draw once you break it down to basic shapes, using as few lines as you can.

Have fun coming up with your own strange versions of existing cars and other vehicles. Keep the basic shapes and forms in mind as your drawing comes together, and always imagine the object as a three-dimensional form. Use vanishing points and a ruler to get the angles right.

Become a Car Collector

Collect photos of cars and other vehicles. Put them in page protectors and organize them in binders. Try to find images of the same model of vehicle from every angle imaginable. Better yet, go out and take your own photos. Don't forget to get a photo of people sitting in the car so you know how to place them. If you are at a loss for fresh ideas, combine features of different vehicles to create something unique.

Sporty Car

Manga heroes need to get around. Sports cars are a popular choice because they are stylish and sexy. This car is based on a real sports car, the Mercedes-Benz SLK, but design details from other sports cars have been added to create a more original ride.

1 Use light guidelines to block in the shape of the convertible. Quickly add details as you see fit. Some of the objects will be cleaned up as you work. Even though the tires won't show completely in the final drawing, draw them through to get the shape right. The car's right front end is angled toward us, so make sure the front tire and passenger seat look bigger.

2 Mix, match and invent details to create the car of your dreams. Make sure that the details wrap around the form of the car so they look like a part of the three-dimensional vehicle, not "pasted" on.

3 Make the metal look reflective with harsh divisions of light and dark. Referring to photos of cars will help you with this.

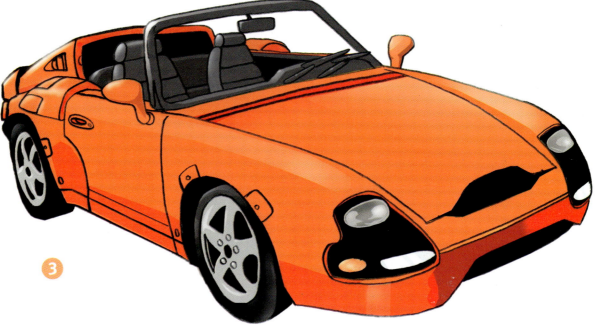

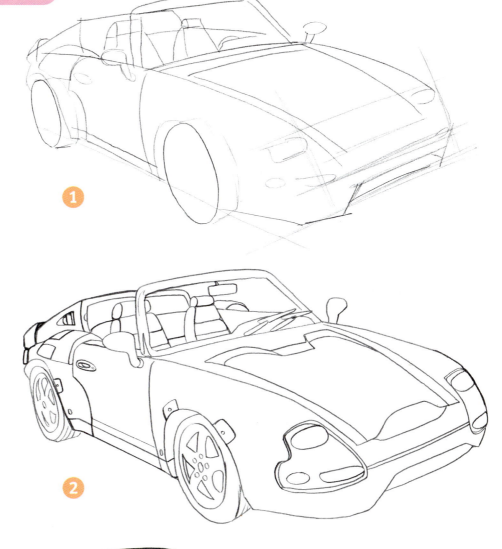

Flying Car

W ho says a car can't fly? As you design a flying vehicle, consider how it flies. Will it use huge jet engines, retractable wings, antigravity crystals? Then work these details into the drawing. Even though this vehicle doesn't exist in reality, don't be afraid to use real vehicles as models when you draw.

1 Even though you may want a curvy car in the end, that doesn't mean you have to start with one. You might find that starting out with straight lines you can draw with a ruler is easier, and you can always smooth the corners into curves later.

2 At this point you can make the boxy lines sleeker. Add details much like you would for a spaceship or a mecha. Air vents, tubes, flaps and sensors add to the futuristic look of the vehicle and give the viewer an idea of what it can do.

3 You may want to streamline the vehicle at this point, removing some details that ruined the lines or felt too forced. It should look cool, but you don't want to upstage the stars of your story: the characters.

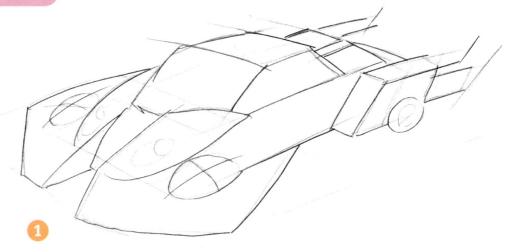

1

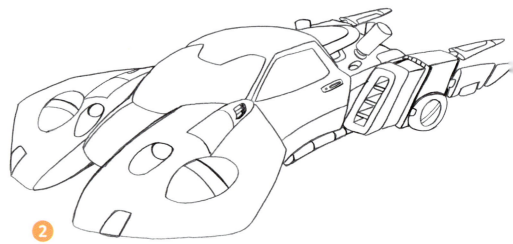

2

3

Sky Cycle

If a car can fly, then why not a motor-cycle? It's a simple matter of taking something familiar and turning it into something special. The tricky thing about drawing a cycle is positioning the rider so that the character appears to be sitting naturally on the vehicle. You don't want the rider to look as though she were just plunked on top of the drawing of the cycle.

1 Draw through the vehicle to show the entire figure of the rider, keeping her proportions in mind as you go. Even if part of her will be hidden by the vehicle later on, it is important to know where all the parts of the figure are so you can make her sit naturally. Her left foot can be seen under the front of the cycle.

2 Clean up your lines as you add more detail. Don't forget to consider how the cycle works. This sky cycle has a big engine on the back, but it also has some large wing attachment on the bottom. This wing might help stabilize the vehicle or it could be the primary antigravity unit. Look at real motorcycles to help with details like the handlebars and the engine block.

3 Be careful: the more highlights you include, the shinier and more metallic everything will appear. Shade the drawing bearing in mind that you must keep the direction of your light source very clear in all of your drawings.

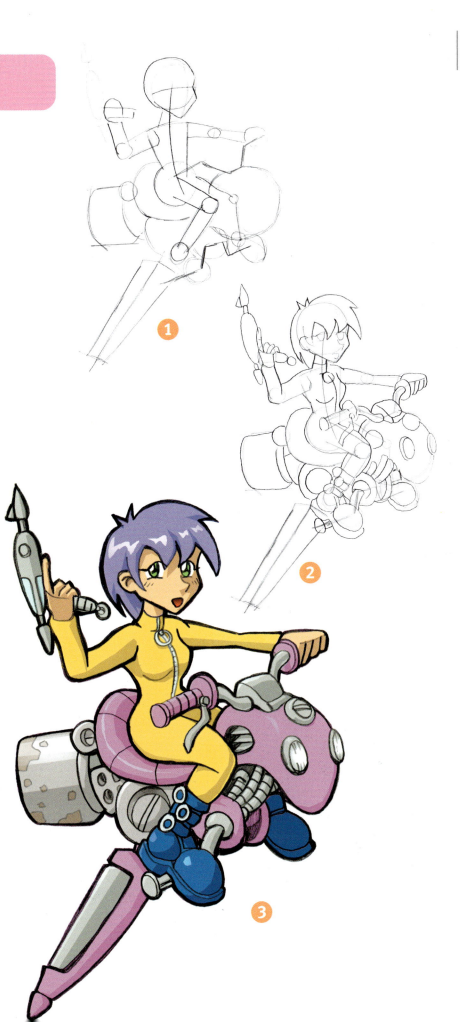

Good-guy space fighter

Space fighters don't really need to be aerodynamic because there is no friction outside of the atmosphere. But don't let a little science ruin your science-fiction manga! Manga space fighters are usually streamlined and sleek, resembling modern jet fighters.

1 Use perspective rules and guidelines to make the fighter appear to be screeching through space. (There is no sound in space, either, but that shouldn't stop you from using all kinds of sound effects.) Block in the shapes loosely, keeping your lines exploratory and expressive. You want to capture the essence of the design with your first lines.

2 Carefully erase all of the unwanted lines, clean up the main lines, and then begin adding details. Some perspective lines still remain so that the final details will be precise. The technology should look possible but futuristic at the same time.

3 Colors and shading are especially important. Make sure the fighter stands out against a black star field.

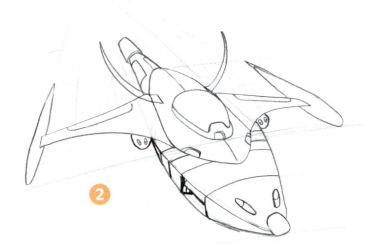

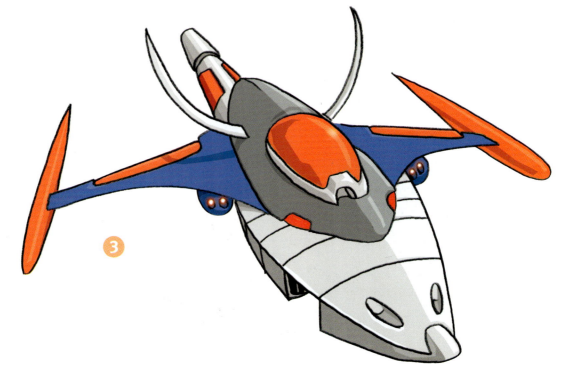

Pirate
space fighter

Try to make the spaceships and fighters of the opposing forces look very different from those of the good guys. The reader should be able to figure out who the good guys and bad guys are almost immediately.

1 Use perspective lines to make the object appear to exist in space, flying toward the viewer.

2 Some aspects of manga are not known for their subtlety. The skull and crossbones design makes very clear which side this fighter is on. It also uses part of the ship to look like teeth. Cool!

3 The skull design is even more striking with strong color. The ship is recognizable as a space fighter, but has a unique wing design and different colors that distinguish it from the good-guy ship.

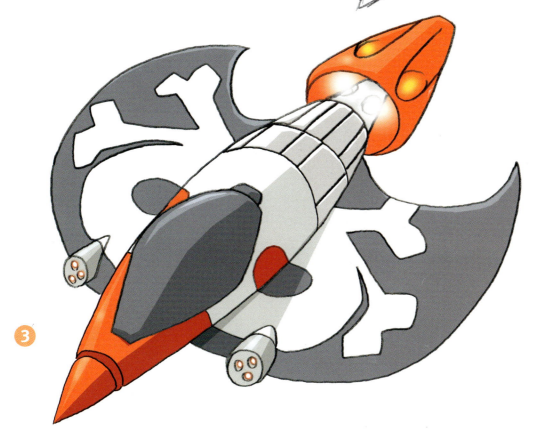

good-guy Spaceship

*T*he good-guy spaceship and space fighters should have some features in common so that it's easy for the viewer to see that they're on the same team. Have them share a similar color scheme, as well as several basic design features.

Manga spaceships may be any shape you like, but they often adopt the characteristics of ocean-going vessels. Include lots of laser turrets and missile launchers on the mother ship to help defend it against the vicious space pirates.

1 Block out the basic shape of the spaceship using perspective lines. Refer to design elements from the space fighter for inspiration, but remember that this ship is huge! It is a battleship in space. It should appear clunky, ponderous and not quickly maneuverable.

2 Clean up the details and begin adding the necessary spaceship components, including the bridge, main engines and sensors. Manga space battles resemble World War II-era ship-to-ship combat, with massive blasts of artillery from the large spaceships and waves of fighters whizzing past their surfaces to fire at close range. A main ship's artillery should be both massive and powerful.

3 Try to keep the color schemes the same for fighters and massive spaceships that are on the same side. Lighting in space can be harsh, with very strong lights and darks.

1

2

3

pirate Spaceship

*T*ake a cue from the smaller pirate fighter when coming up with the design for the larger ships in the pirate fleet. Keep the ships big and impressive, but don't forget that they fight in a space more like the ocean than an airless void. The ships need massive artillery and smaller banks of many guns to fill the darkness of space with blasts of light.

1 Block in very basic geometric details. Pirates don't have the benefit of mass production and regular maintenance for their spaceships. They steal what they can get or buy the rest on the galactic black market. It makes sense that the ship should appear simpler and be easier to use.

2 Add the skull and crossbones design from the fighter to clearly link the two ships. The reader should be able to distinguish the pirates from the good guys easily.

3 Use light and shadow to add depth and detail to the ship. This vessel has enough going on to make it look interesting, but is simple enough to draw from almost any angle. Try drawing details of sections of the ship. You could use them when you zoom in on smaller parts for different scenes in your story.

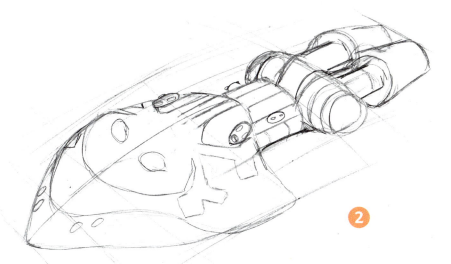

the basic elements of a manga page

Once you have all of your characters established and a storyline in mind, it's time to hit the drawing board. Before you get started, let's take a look at the basic parts and conventions of a manga comic book page.

Surface
Most comics are drawn on 11" x 17" (28cm x 43cm) two-ply bristol board sheets. The artwork area is usually 10" x 15" (25cm x 38cm).

Panel
One of the many illustrations arranged in a sequence to tell a continuous story.

Gutter
The space between the panels. It is important to keep your gutters consistent.

Narrative Caption
Narration for the comic, usually written in rectangular boxes that overlap the artwork.

Word Balloon
The words spoken by the characters. The direction of the arrow indicates who is speaking. A dotted-line balloon means that the character is whispering.

Thought Balloon
A cloudlike balloon that reveals the thoughts of the character the little bubbles are coming from.

Panel Variety
Change the shape of the panels from time to time to hold the eye of the reader.

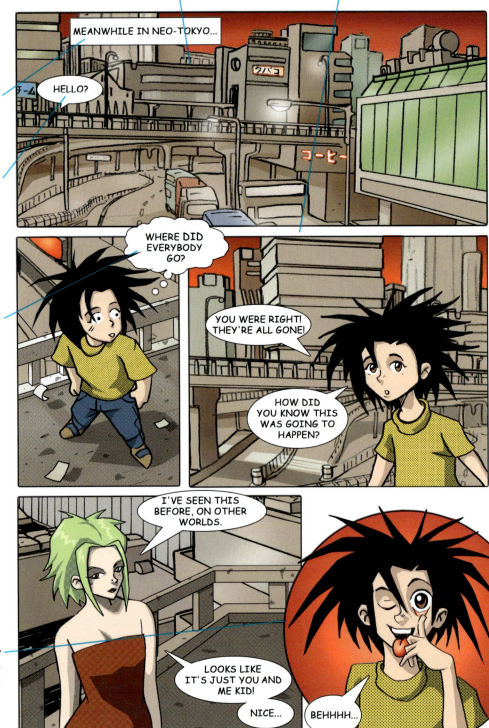

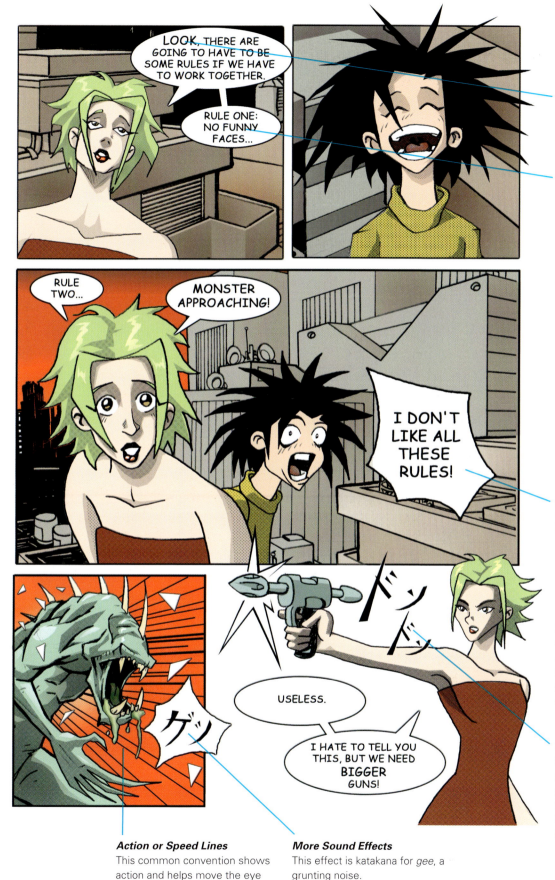

Bold Lettering
Any lettering that is larger and/or darker than the other lettering signifies that those words are louder or stressed as the character is talking.

Splitting Up Text
Too many words in one balloon can be hard to read and may ruin the pace of the story. Split up the text for clarity and impact. Try to limit yourself to one sentence or idea per balloon.

Loud Voice/Yelling Word Balloon
This balloon is jagged and the lettering is much larger.

No Panel Border
Occasionally breaking characters out of the panels creates a more dynamic page and lets the artist squeeze in more images of the characters.

Sound Effects
Sound effects are words that represent sounds. The sample shows Japanese sounds written in the Japanese script of katakana. This effect is katakana for *don*, the sound of gunshots.

Action or Speed Lines
This common convention shows action and helps move the eye around the page.

More Sound Effects
This effect is katakana for *gee*, a grunting noise.

planning a *Comic Page*

Have a sense of the "big picture" before you start drawing. Try to plan everything before you begin your first page. Know exactly how the story will end in every detail, and then fill in the rest of the story.

You might use a script or a thumbnail layout to plan your story. A script is a written description of everything that happens or is said in the comic. Use examples from movies or plays as a guide. The script has the advantage of ensuring that every piece of dialogue and action is accounted for and planned. One disadvantage of the script is that there is an abstract sense of what can fit on a single comic page, and often the writer frustrates the artist by trying to include too much in one page or panel.

Some artists prefer to use thumbnail layouts to map out the comic. Thumbnails are small drawings that are tiny versions of your final pages. You can work out issues of composition and pacing at this stage. The drawings do not need to be fully finished works of art; even stick figures will serve the purpose.

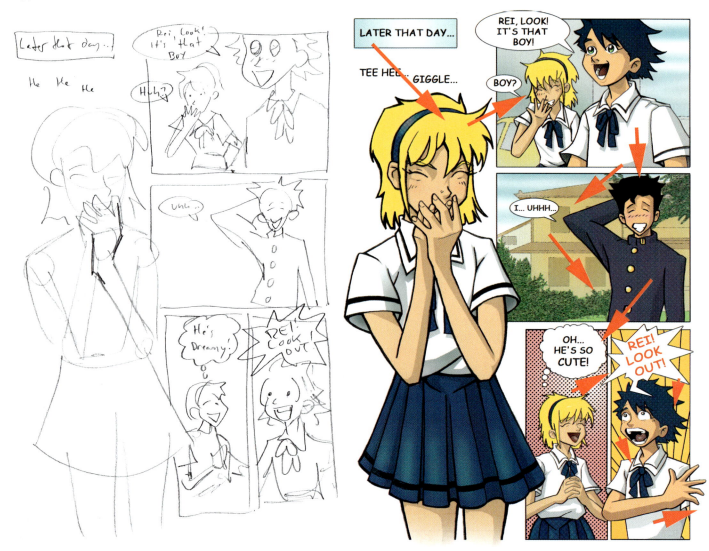

Rough Thumbnail

Manga has a fairly open approach to page layout and composition. When you are setting up your layout, try to avoid the standard "comic strip" look: equally sized panels lined up one after another. Feel free to draw panels without borders. You might even have full-body shots of characters with a series of panels running down the side.

Final Page

Avoid clustering your focal points in the center of the page. You want to control the reader's eye and lead it across the page very carefully. Each panel should lead to the next, as in the example shown here.

designing
Dynamic Panels

Not every panel in your comic must be an artistic masterpiece. That would be like trying to make every sentence in a novel a literary triumph. Sometimes a panel merely serves to move the story along. Manga artists usually save their focus for the "money shot": the key image that sums up the events of the page.

Manga has become much more dynamic with the use of cinematic camera angles like what you'd see when watching your favorite movie. Variety keeps the page interesting. A series of talking heads or full figures standing around panel after panel will get old quickly. Two ways to keep your panels dynamic are by using the Rule of Thirds and different points of view.

The Rule of Thirds

The panel is like a picture frame that surrounds the subject. Avoid placing your main subject or focal point in the dead center of the panel. Use the Rule of Thirds instead: Imagine placing a tic-tac-toe grid over the panel. The focal point of any panel should be in one of the areas where the lines intersect.

Bird's Eye View

In this view we are looking down at the subject. The horizon line is high, and we are either tall or at a higher elevation. This view is effective for making the subject of the drawing look anxious, unsure or weak, but it can also be used to show another character's point of view.

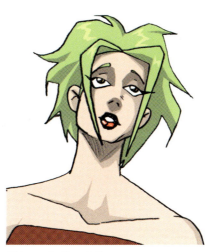

Worm's Eye View

In this view we are looking up at the subject. The horizon line is low, and we feel pretty small. This view is excellent for making the subject of the drawing look imposing or powerful, but it can also be used simply to show a lower point of view.

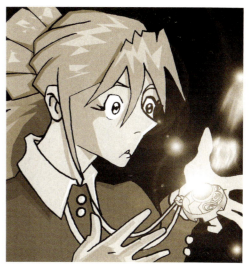

Straight Ahead

In this standard view we see the subject head-on. The horizon line is in the middle of the picture, so there is no distortion of the image. We are on equal ground with the character.

basic
Panel Shots

Just like a television or movie director, the manga artist must consider whether the scene is going to be seen up close or from far away. These issues are usually dealt with in the script or the layout. Change the shot from time to time to make the page interesting and to place emphasis on specific elements and details.

Long Shot (Full Figure)

This shot shows the entire figure or figures in their surroundings. The details of the background are still important but should not compete with the focus of the panel.

Extreme Long Shot (Panoramic)

This shot establishes the setting and the character's relationship with it. Use proper perspective and create a full depth of field with a foreground, middle ground and background.

Medium Shot (Waist Up)

This shot allows for a clearer view of details, expressions and actions.

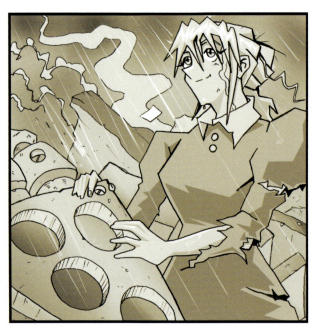

Knee Shot

This shot is useful for showing costume details or clarifying complex actions.

Medium Closeup (Chest Up)

This is often the most common shot used by beginning manga artists. It shows a fair amount of information in a simple way and is easy to draw.

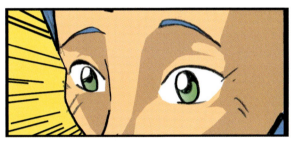

Closeup

This panel shows the head of the figure, or another detail such as hands, feet or an object. It is useful for showing reactions, expressing emotions or emphasizing the significance of an object.

Extreme Closeup

This shot focuses even more closely on a set of eyes or another facial detail, or on a specific element or object.

Framing Fun

Manga artists have the advantage over the photographer or filmmaker because they are not dependent on what they see. They are only limited by their imagination and technical ability. The artist has ultimate control over what a character looks like or does.

Have fun framing your subject within the panel. Tilt the angle to make the image more intense or twisted. Use models or photo references when you need them, but approaching figure drawing from a construction standpoint allows you to draw anything from any angle.

Avoid breaking the figure out of the panel too often. Although this looks dynamic and exciting, it can be a telltale sign of an amateur artist trying out a new trick if it's overused. It is a powerful tool that draws attention to the action, but use it too much and it will lose its impact after a while.

Pacing *and* panel flow

Manga and other comics are really just a form of visual storytelling. The panels set the pace of the story, much like a drummer sets the tempo for a song. Mix up the size of your panels based on what is important to the story. A succession of small panels, like many quick shots in a film, will speed up the pace. Larger panels demand attention and will hold the eye longer if they have more detail and a fully realized space.

If you are building the drama and suspense of the moment, draw a series of small, narrow panels. If you are reflecting on a long, lingering shot, make the panel larger and wider. Establishing shots that set up the location of the story are usually large and wide. Keep readers engaged in a scene that continues for a few pages by changing the point of view or angle with each new panel.

Too many complicated panels on a page can ruin good storytelling. The reader might zip right through your story without catching key information. A grid approach—six to nine equally sized panels spaced evenly across a page—can build a steady pace but can become tiresome and restricting at times. Do what will advance the story at the right pace. You can tell only so much story on one page.

Watch how the following manga pages lead the viewer's eye around the page, pacing the story as it is revealed.

The page has five panels: an establishing shot, an action/reaction shot, a detail shot, a further reaction shot and a final panel that moves the story along.

The amount of detail in the first panel holds the reader's attention.

> I HAD BEEN ASLEEP FOR ONLY A COUPLE OF MINUTES. MY NECKLACE DANCED, BURNING WITH A FRANTIC ENERGY. IT WAS AS IF IT WAS TRYING TO TELL ME SOMETHING IN A LANGUAGE I HAD FORGOTTEN I KNEW.

AHHH!!!

OHHH...

GORGEOUS...

IT'S NEVER DONE THAT BEFORE!

...

The borderless panel really stands out. The reaction of wonder and awe is the focus of this page.

Manga readers will often read in the direction characters in the panel are looking. They will be directed by the gaze and want to see what the character is looking at.

Contrasting areas of light and dark attract the eye of the reader. This glowing amulet becomes the focus against the dark background.

Small panels placed side by side move the reader along very quickly through the page. Unusual or large panels hold the eye of the reader and become the focus of the page.

This page starts with action. Try to move the action in the direction you want the reader to look.

What Readers Notice First

Compositional focal points. The Rule of Thirds applies to the full page layout, not just panels. Use this rule to find the best place to put important images.

Writing. We are attracted to words first. That's where we will look before noticing the art.

Size. Larger images capture the reader's attention.

Dark spots. Areas of shadow or black will grab the eye and lead readers through the story.

Detail. Detailed artwork, such as folds in a cape or complex technology, will attract the eye.

Faces. We are naturally attracted to other people's faces, especially the eyes.

Contrasting areas. Simple areas contrasted with complex areas catch the eye.

Distortion. Things that look funny, unusual or deformed attract attention.

The old man looks up at the focal panel of the page, giving the last panel even more impact.

This panel stands out because it is the largest, has the greatest contrast between light and dark, is highly detailed, and because the mecha breaks its boundaries.

Panels that gradually zoom in on a character or setting help to establish the mood. They also are just different enough from each other to keep the reader interested while you tell your story.

word balloons and **Lettering**

There is an infinite variety of ways to put words in your characters' mouths. Word balloons come in all shapes and sizes. The shape and style of the balloon tell the readers how the words are spoken.

If you are not using a computer to do the lettering, then you must make sure that your lettering is done clearly and carefully. Spelling mistakes will reflect poorly on your abilities even if the art is beautiful.

Try making an alphabet style of your own based upon what you are comfortable with. You'll discover personal touches that will add some character to your lettering. You can also be much more expressive with hand lettering. Emphasizing or bolding certain words helps add emotion and tone to the dialogue.

If you really want to get complicated, you could give certain characters unique lettering styles. This lets the reader know who is talking and says something about the personality of the character. Sometimes special effects can be used to express emotion. For example, a "thank you" written with icicles hanging from the letters cleverly indicates that the speaker is giving the cold shoulder or is insincere.

Oval
Normal speech.

Dotted-line Oval
Whispering.

Cloud
Unspoken thoughts.

Soft Jagged Line
A loud voice.

Box
A mechanical or technological voice.

Sharp Jagged Line
Yelling.

ABCDEFGHIJK
LMNOPQRST
UVWXYZ
!?1234567890.,;"()

Computer Fonts
Handwritten lettering is generally used for manga, but computer-generated fonts such as Comix (shown) are used by most professionals. If you are going to letter your comic by hand, you should make a sample alphabet so that your letters remain consistent.

Lettering Tips

If you're not using a computer to letter your comic, you'll want to letter the pages after penciling and before inking. A few tips:

- Carefully print out each word in uppercase letters.

- Try to keep the style and size of the letters consistent. Imitate an existing font or make one of your own. Use a ruler to make the letters the same size every time.

- Start with the letters first, then draw the word balloons. If you draw the balloon first, you may run out of room for the words.

- Create stencils to help you draw consistent balloons, or try using a curved ruler.

Sound Effects

Sound effects are used to express the noises in manga. They are examples of onomatopoeia: words that sound like what they mean. For example, an explosion would make a *BOOM!* sound and a soccer player hitting the grass would make an *OOF!* noise. Sound effects are written in large, expressive text that dominates the panel they are placed in.

At one time, many companies that translated and published manga used to flip the page so it could be read from left to right. They also translated the sound effects and went through the painstaking process of changing the onomatopoeic words into text. Today, many translators and publishers are remaining loyal to the original vision of the manga artist and are presenting the pages as they were drawn. That means that the reader must read the book and scan the pages from right to left.

Many translators are also leaving the sound effects in the original katakana form of Japanese writing. If you're interested in using these symbols to help your manga look more authentic, you can locate a phonetic chart of the forty-six symbols and the fifty sounds that can be made from them. They can be found in most good books on conversational Japanese, or on the Internet.

Of course, you could just write the sound effects in English. Choose a font and style that reflect the nature of the effect. Have fun with sound effects, but don't overuse them or they'll lose their impact.

Typical sound effects you've probably seen before…

…and some Japanese ones you probably haven't!

Don = the sound of gunfire

Gee = a grunt or exclamation

Gon = a sharp punching sound

Niko = the sound of smiling

Nyunyu = the sound of a wide grin

Gata Gata = heartbeat

Shi—n = the sound of silence

Ahahahahaha = laughter

Unique Features
commonly found *in manga*

There are some things that readers find in manga that they may not find anywhere else. Use these unique characteristics in your own work to add some flavor, but don't overdo it. Here are a few samples of elements that show up again and again in manga.

Speed Lines ▷

Speed lines are not exclusive to manga but are used in it very often. Speed lines draw your attention to the action of the characters and make it look more dynamic. They also simplify the task of drawing a complicated background.

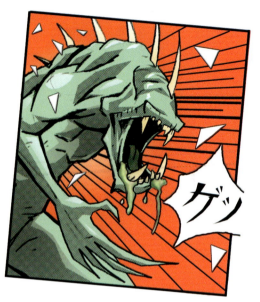

Speedy Feet ▷

This is shorthand for moving really fast. A cloud of dust will usually form below the running character and multiple feet show just how fast the character must be moving. Used primarily in comedies or Super Deformed manga, this convention is cute and a useful shortcut.

▽ The Stunned Fall-Over

When unbelievable or ironic news is given, the listener may fall over with only his feet sticking up in the air. This action is best done in a series of two or three panels. The person who fell might be bandaged up or nursing a bump on the head in the panel after the fall.

BEHHHH...

▽ Akanbee

This disrespectful gesture is used usually by kids or younger heroes. The index finger is used to pull the lower lid of the eye down and the tongue sticks out. The character then says "Bleah!" or "Behhh!"

◁ The Transdimensional Mallet

This big wooden mallet is plucked out of nowhere and used to pummel someone who has said or done something offensive. This attack is just for effect, and though victims may appear bruised and bandaged in the next panel, they usually recover by the following page.

Childishness ▷

Manga characters often display a goofy immaturity. This may be to reinforce their innocence, to lighten a serious scene, or simply to add a sense of cuteness to the story. Childish antics can include pulling faces, throwing a temper tantrum, sneezing when everyone's trying to be quiet, or generally acting like a brat. The ultimate example of this childishness is when the characters turn super-deformed and run around.

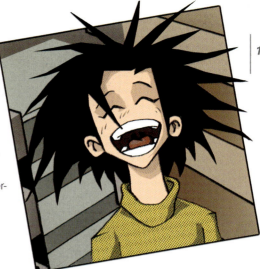

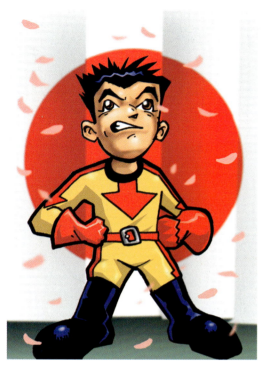

▲ Falling Cherry Blossoms

The *sakura*, or cherry blossom, is a national symbol of Japan. It is often used in a patriotic fashion as a sign of confidence or victory. It is sometimes combined with other national symbols such as the Japanese flag or Mount Fuji. An alternate meaning for this symbol in shoujo manga is to reinforce a sense of longing or sadness. Falling snow also can be used to represent the melancholy or nostalgia of a panel.

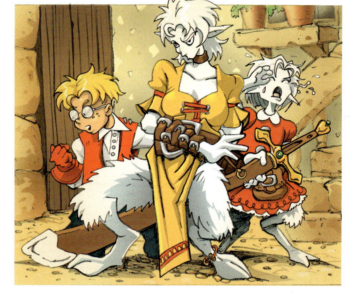

◁ The Cool Staredown

Some heroes don't even need to physically attack their opponents; they can win just by staring them down. This is the ultimate "if looks could kill" glare.

Food ▷

In manga, you might see a martial artist trying to fight off an attacker while eating a sandwich, or a girlfriend who is embarrassed about a disastrous meal she has prepared for a boyfriend. Many shoujo heroines eat huge amounts of food or are tempted by treats to the point that they often ignore the Big Bad. Sometimes food is used as a peace offering or a gift to break the ice.

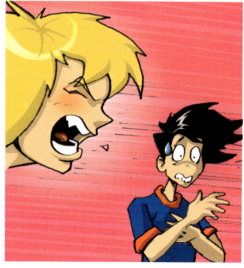

▲ The Big Head Yell

The head of an enraged or outraged character may expand to fill the entire panel and dwarf the target. The eyes of the person yelling are usually fierce, and the teeth are bared and often pointy.

the *business* of
Making Manga

Sure you can share your manga drawings with family and friends, but you might dream of someday making your hard work pay off literally. Well, it isn't that easy. It takes years of practice to become an overnight success in comics. There are many ways to get your work out there, but only some of them include making any money.

If you aspire to someday get paid to make manga, here are the key steps you should plan to take.

Step 1: Know Your Strengths and Weaknesses

Many projects never see the light of day because the creators are crushed by the weight of the task that rises before them. Creating cool character designs is only part of the job. You must know how to produce sequential art that tells a story. This is the only way that your work will become professional enough to publish.

If you can draw but can't write worth beans, get someone to write for you. If your drawing needs work, get a friend to help you. Don't try to cover up your weaknesses; work on them!

Step 2: Meet People and Get Feedback

Get to know your fellow artists. Build a community of peers that will challenge your creative skills and support your work. Put notices up in your school or in comic bookstores. Post your artwork on an Internet Web site for others to critique. Go to an anime or comic book convention and talk to the people in the "artist alley." Meet the folks who create comics. Don't waste your time lining up to see the hottest new artist scribble his name on a copy of his latest comic.

Find the editors and the writers. Many artists will be glad to look at your portfolio and offer comments.

Step 3: Promote Your Work

Many artists sell small print runs of mini-comic books, made from folded 8½" x 11" (22cm x 28cm) paper, at conventions or comic book shops. Try to get your minis into the stores by giving them a great deal. Revenues usually are 40 percent for the seller, 60 percent for the creator. You might even go 50/50.

If you give your minis away, don't give them to just anyone. Give them to industry people: writers, artists, editors and publishers. They are a portfolio designed to show off what you can do. Make sure the appropriate contact information is within each comic so people know how to reach you.

Consider posting your manga regularly on the Internet. Seek out free Web site hosts. Create an online comic and advertise for it on every bulletin board and list-serve that even remotely relates to manga. Keep updating the comic. Even if you only post one page a week, in one year you would have a 52-page comic and maybe a loyal following.

Step 4: Be Persistent

Look at the credits page of your favorite comic book. Find out who the editor is and address your communications to this person. Editors ignore hundreds of submissions every day because they are busy and can't read everything that is sent in. That's why you have to send your work all the time. Try sending packages twice a year, then four times a year. They will get to know you and your work. They might even keep some of your work on file. Let them know who you are. Be persistent.

One common mistake artists make is to send only drawings of their favorite characters in cool-looking poses. Publishers want to see storytelling ability. Show a variety of skills. Draw everyday scenes as well as high-tech starships or superheroes. Publishers want to see your range of abilities.

Send a minimum of five consecutive comic book pages. Send copies only, never original artwork. If you have produced a mini, send that too. Check publishers' websites for submission guidelines to follow.

Step 5: Keep Learning

If you can study art in school, do so. Take courses that will give you a wide range of art experience. These can be courses offered in high school, night school, colleges or universities. You may even find art lessons offered at your local community center.

Push the limits of what you can do artistically. Create sculpture, drawings, paintings and computer art. The more education you have, the better. This training can also provide future income in art-related fields. Many comic artists make extra income producing graphic design and illustration work. You can pay the bills *and* produce manga.

Step 6: Stick With It

Be specific with your goals and what you want to do. Don't just tell someone about your manga; show them the twenty pages you've created so far and get some feedback. Telling other people what you are going to do helps put the job in perspective and makes it seem possible. Don't forget to show them what you've done when you finish. And always try to finish what you start.

Look for these exciting
New Titles coming soon
from Impact!

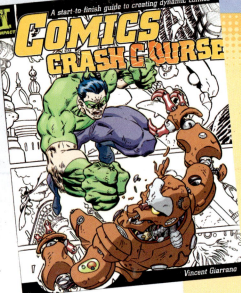

Comics Crash Course

Author Vincent Giarrano shows you how to create superheroes and villains; animals and creatures; robots and vehicles; backgrounds and settings; and much more! This action-packed guide is full of vibrant design and color. Over 20 demos using clear, step-by-step instruction and illustrations will help you create awesome compositions and layouts.

Coming September 2004!
1-58180-533-0, 128 PAGES, PAPERBACK, #32887-K

Superhero Madness

You can draw amazing superheroes and other characters with this illustrated guide. David Okum provides step-by-step instruction and over 50 drawing lessons. You'll learn to create a wide variety of characters starting with the basics of heads and faces as well as figures, proportions and poses. You'll also learn to draw urban and space settings, vehicles including spacecrafts, gadgets, armor and more! Whether you want to draw your characters in cool poses or explore visual storytelling, you'll discover it all right here.

Coming November 2004!
1-58180-559-4, 128 PAGES, PAPERBACK, #33015-K

Manga Secrets

Manga Secrets provides 50 fun lessons for drawing manga, building from basic anatomy to completed comics pages. You'll learn with confidence how to create people, creatures, places, backgrounds, props and visual flash. You'll also see how the pages and cover of a comic book come together step by step from start to finish.

Coming February 2005!
1-58180-572-1, 128 PAGES, PAPERBACK, #33029-K

IMPACT